One Way Traffic · Allen Jones 1974

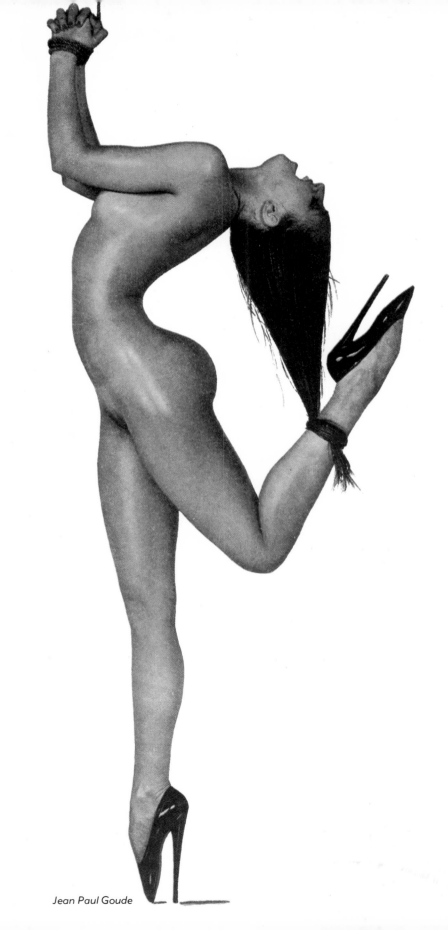

Jean Paul Goude

THE BLUE BOOK

BRAD BENEDICT

Indigo Books, New York

All the Kink that's Fit to Ink!

Jean Paul Goude

Copyright © 1983 by Brad Benedict

Book Design: Tommy Steele
Cover Art: Mick Haggerty

Inquiries should be addressed to Indigo Books, 724 Fifth Avenue, New York, New York 10019

U.S. AND CANADIAN BOOK DISTRIBUTION:
Grove Press, Inc.
196 West Houston Street
New York, New York 10014

OVERSEAS BOOK DISTRIBUTION:
Indigo Books, an imprint of American Showcase, Inc.
724 Fifth Avenue
New York, New York 10019
Tel: 212-245-0981

Printed in Hong Kong

First Printing

ISBN 0-394-62439-4 (Paper)
ISBN 0-394-53017-9 (Cloth)

Library of Congress
Catalogue Card No. 82-82936

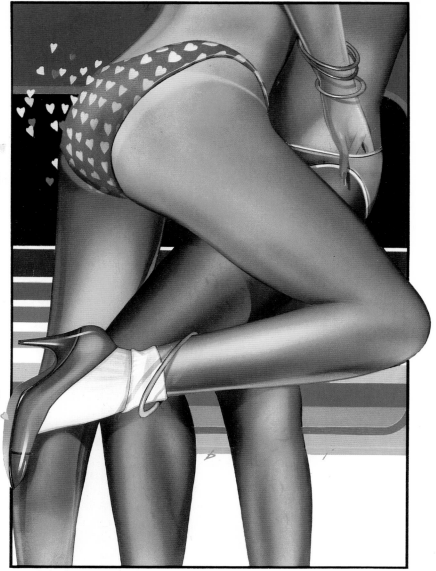

Peter Palombi

Sex. What can I say about sex
that hasn't already been said (or done)?

If you've read the books, seen the movies
and committed the acts, what else is there?

Art. Sex and art—what a combination!
They're only three-letter words, but oh so
powerful and lasting. Enjoy.

—Brad Benedict

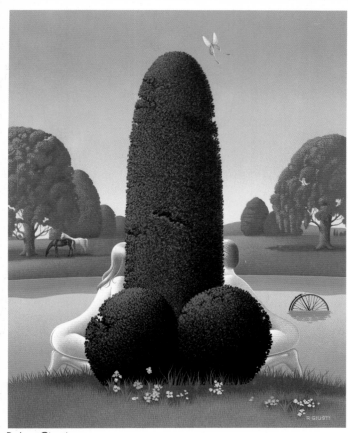

Robert Giusti

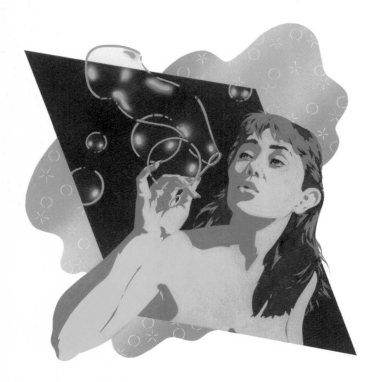

Blow Job · *Laura Smith*

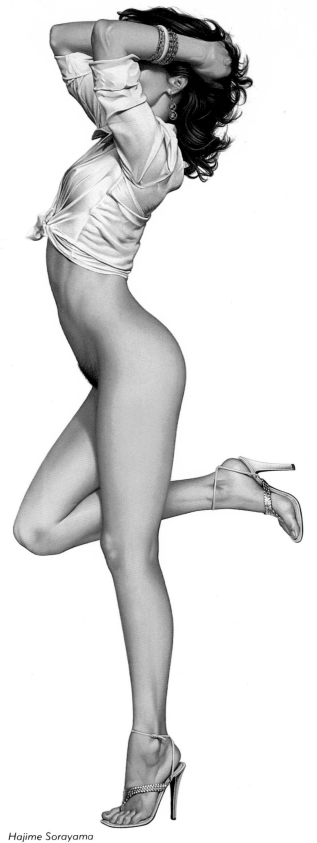

Hajime Sorayama

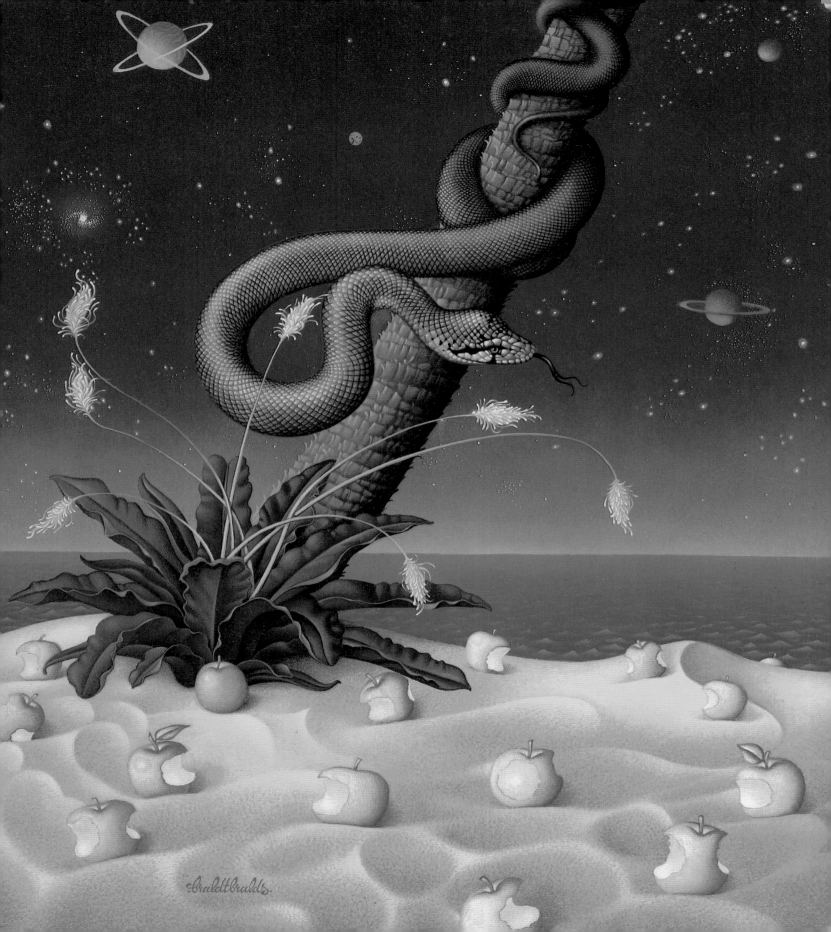

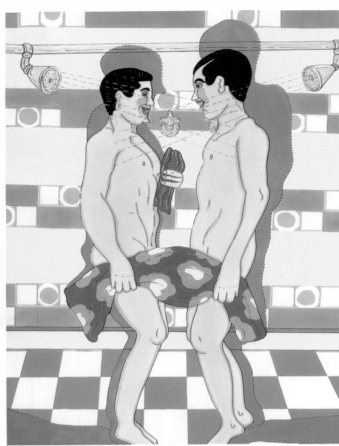

Bruce and Brian in the Shower · *Laurie Pincus*

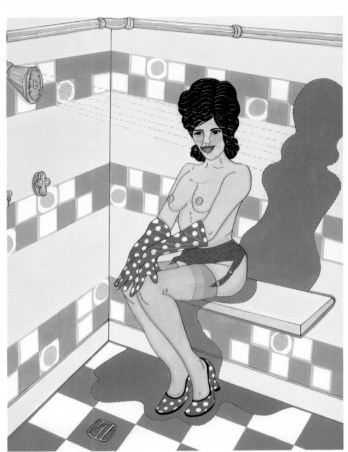

Juanita in the Shower · *Laurie Pincus*

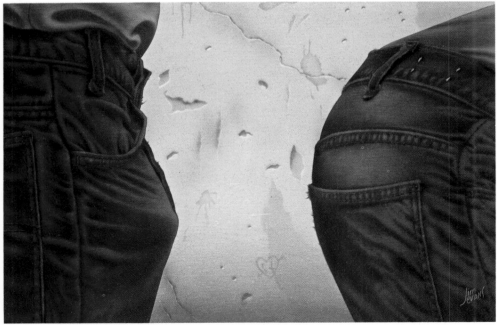

Picking Up the Soap · *Jim Evans*

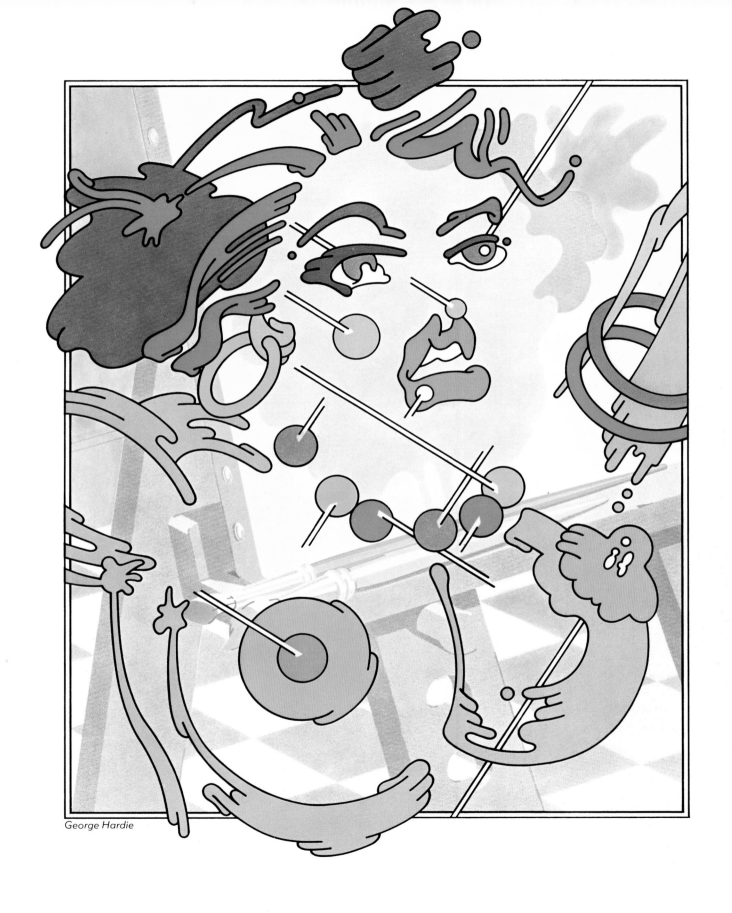

George Hardie

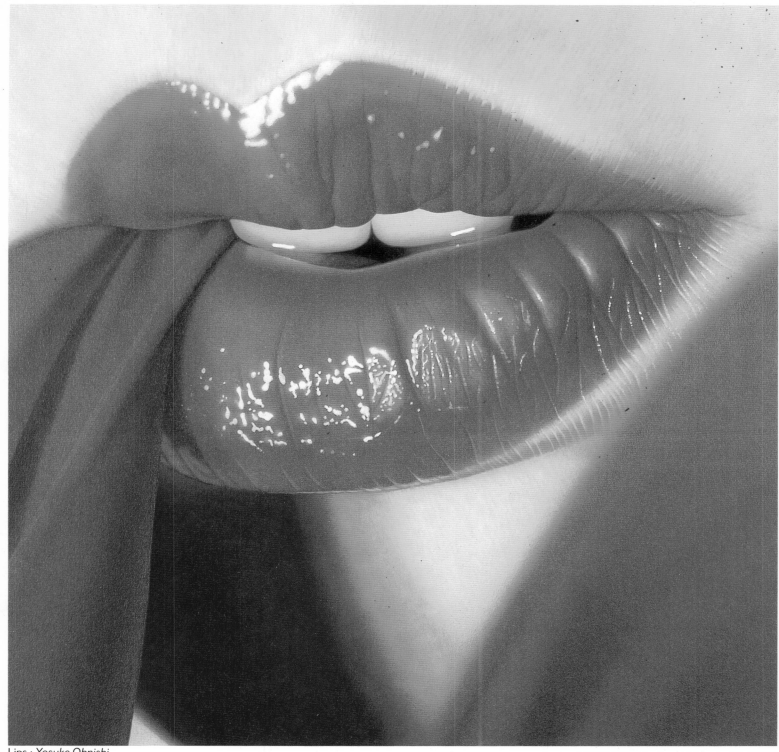

Lips · *Yosuke Ohnishi*

10

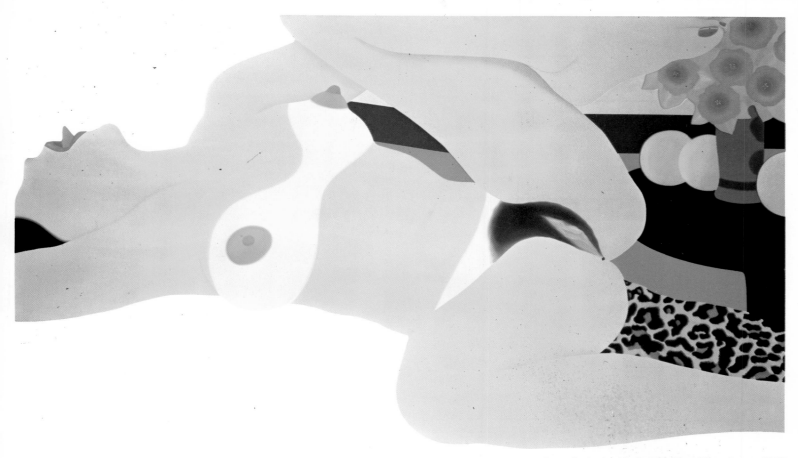

Great American Nude #91 · *Tom Wesselmann 1967*

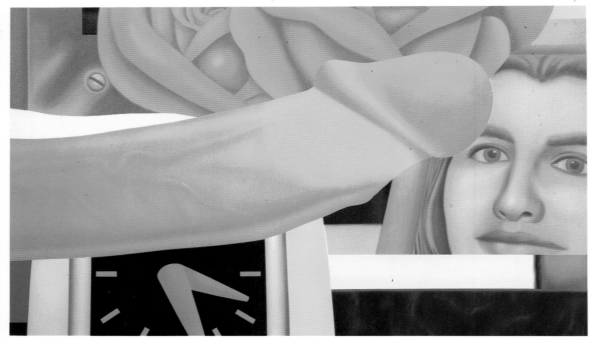

Bedroom Painting #18 · *Tom Wesselmann 1969*

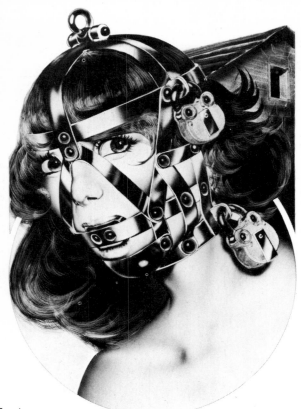

Locks, Stocks,
and Barrels of Fun · Robert Bishop

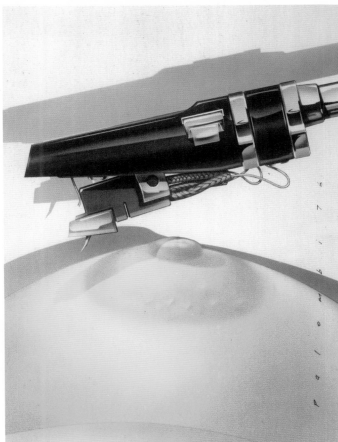

Get to the Point! · *Peter Palombi*

Guy on a Leash · *Dale Sizer*

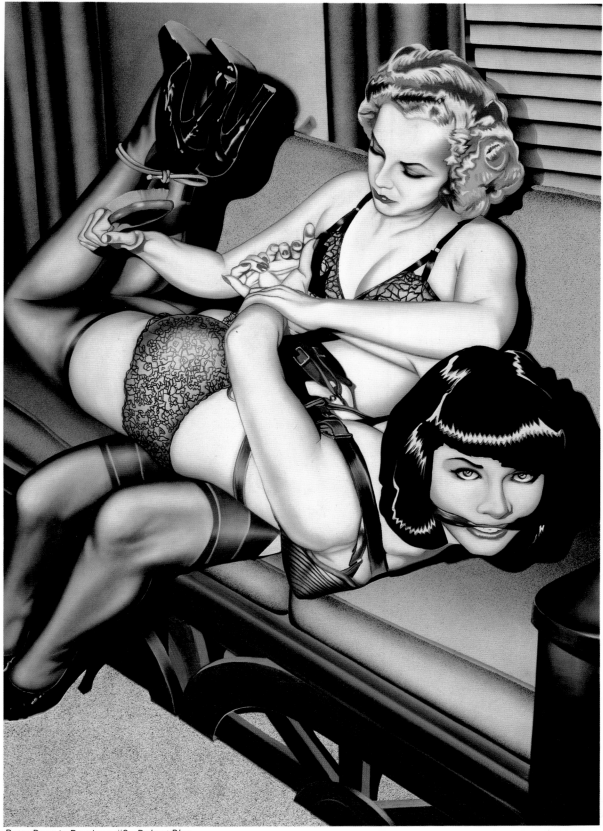

Betty Page in Bondage #3 · *Robert Blue*

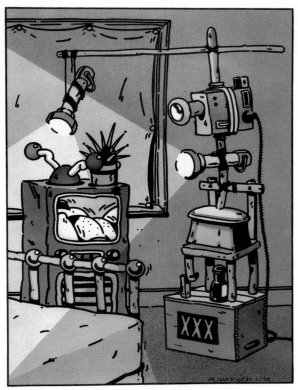

Homemade Video · *Malcolm Harrison*

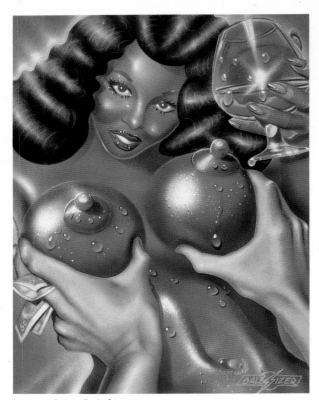

Squeeze Play · *Dale Sizer*

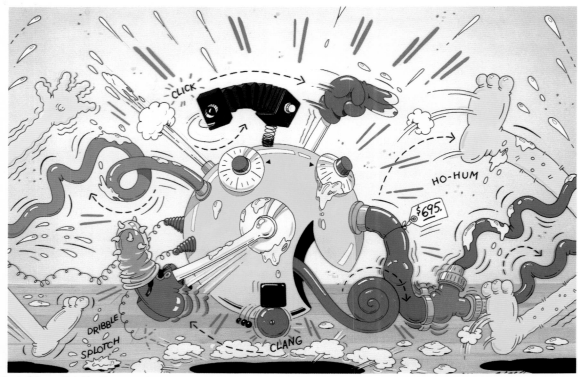

Jack Often · *Bob Zoell*

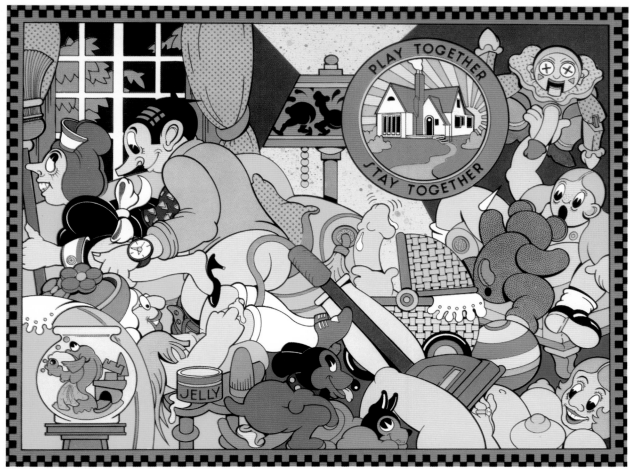

The Family That Plays Together... *Doug Taylor*

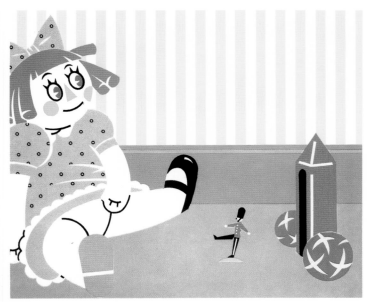

Hello Dolly! · *Anders Wenngren*

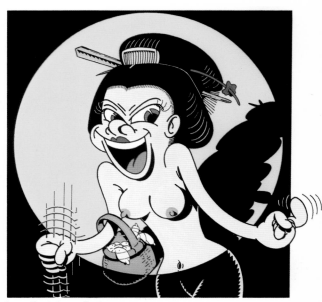

Jap-off · *Johnny Bo Lee*

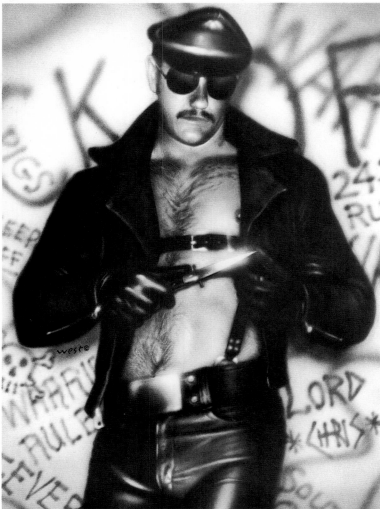

Jim Always Carries a Knife · *Randal West*

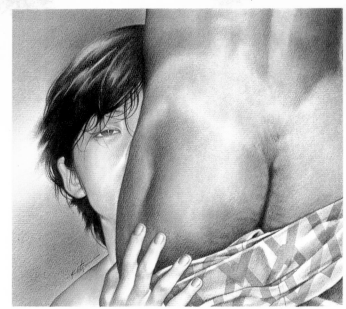

Below the Belt · *Katsu*

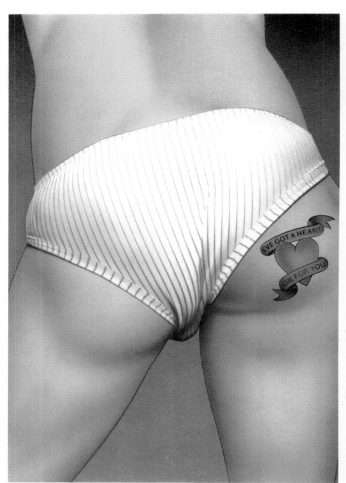

Brian Zick

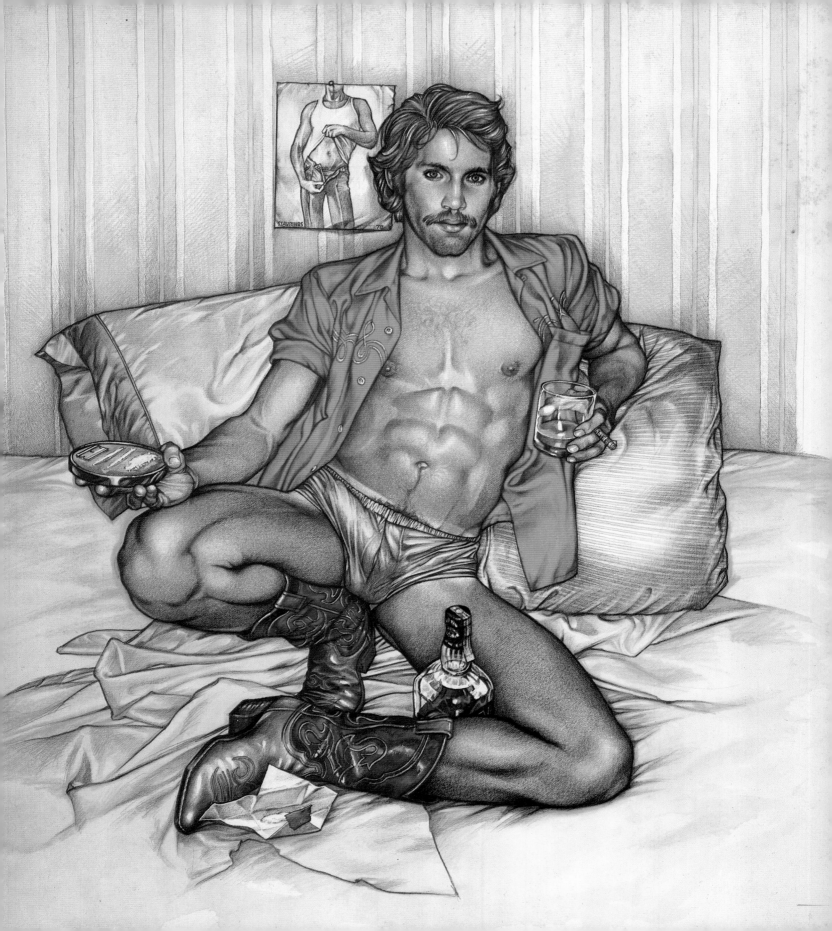

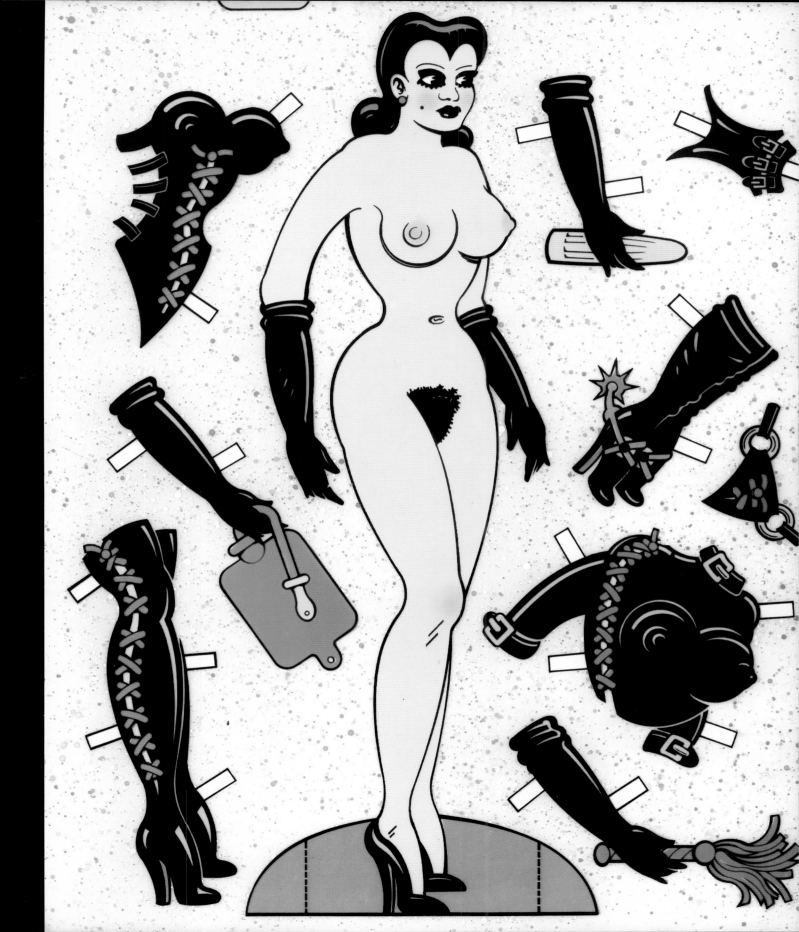

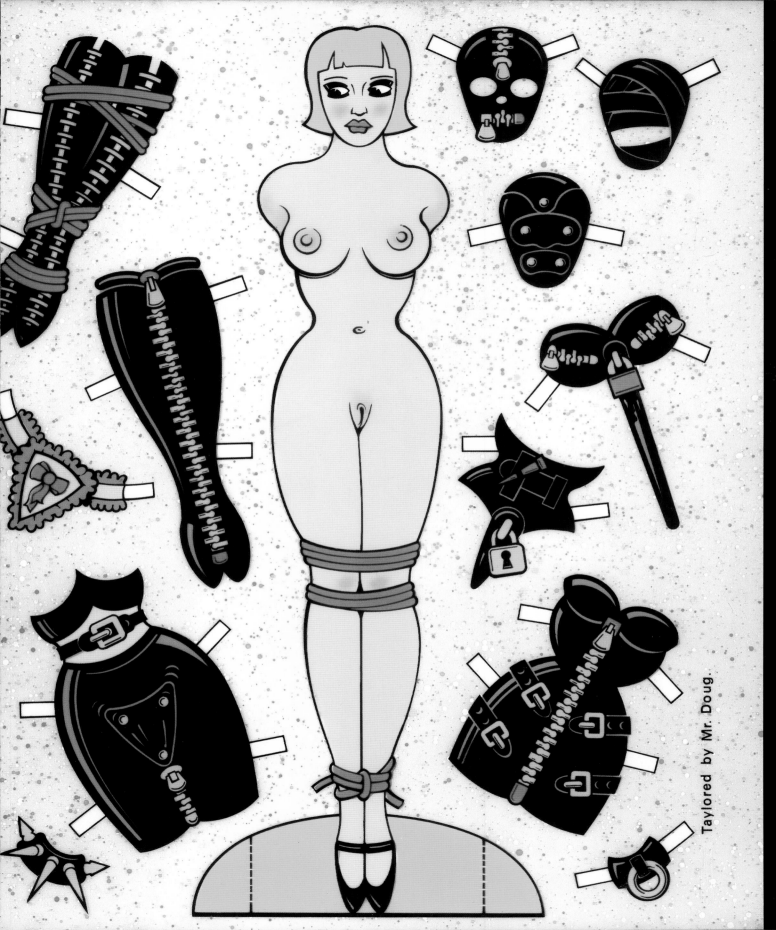

Taylored by Mr. Doug.

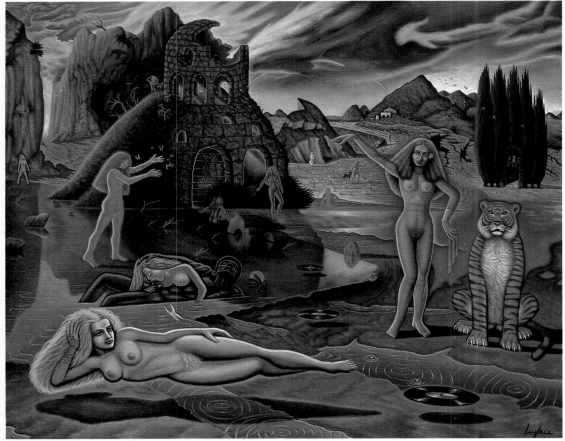

Sinbad and the Garden of Women · *John Lykes*

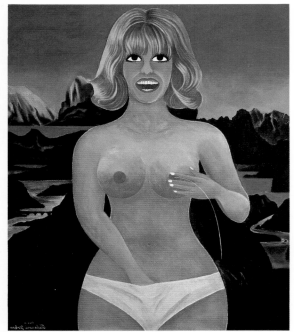

Mona Lisa · *Tadanori Yokoo 1966*

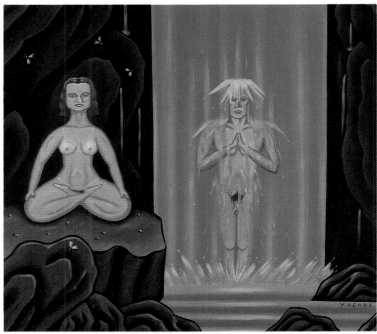

Tina and Masao · *Yosuke Kawamura*

20

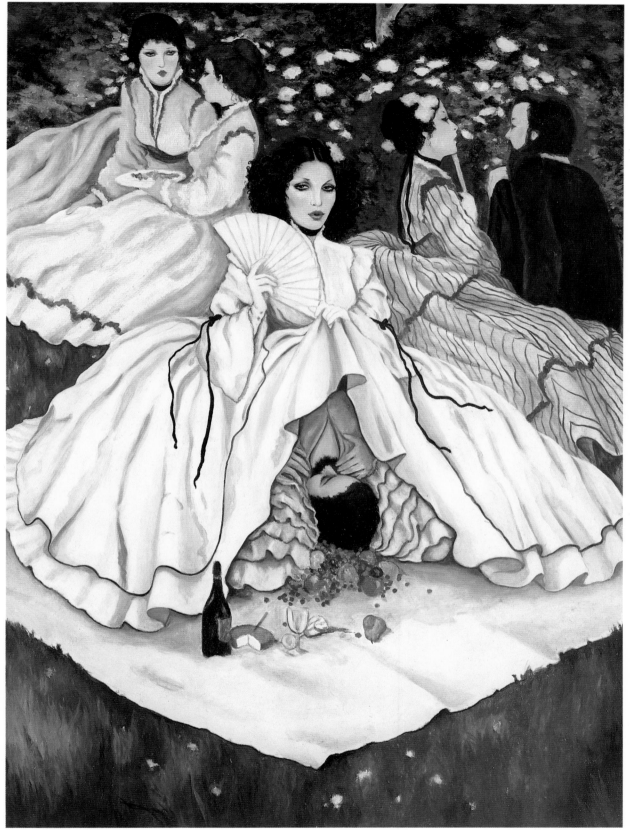

Olivia de Berardinis

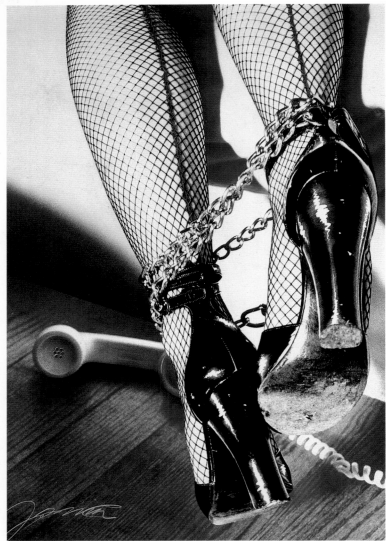

All Tied Up · *Paul Jasmin*

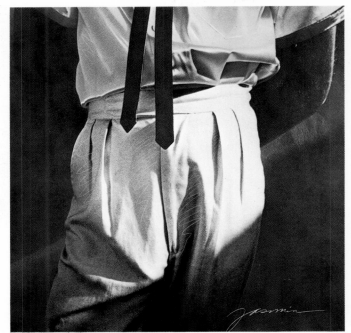

Man · *Paul Jasmin*

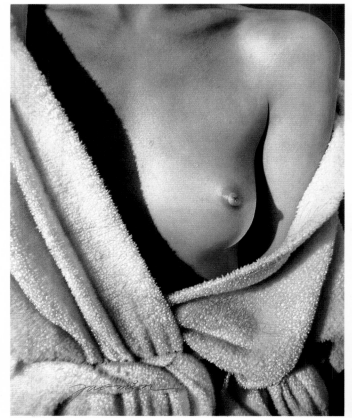

White Shoulder · *Paul Jasmin*

22

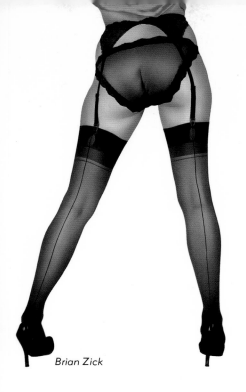

Brian Zick

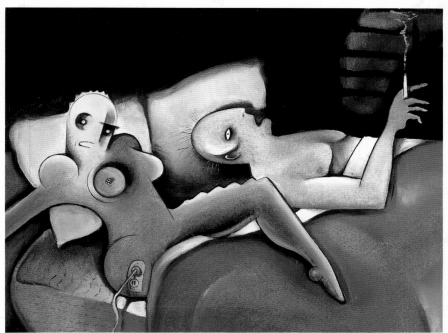

Just Plugged · Lane Smith

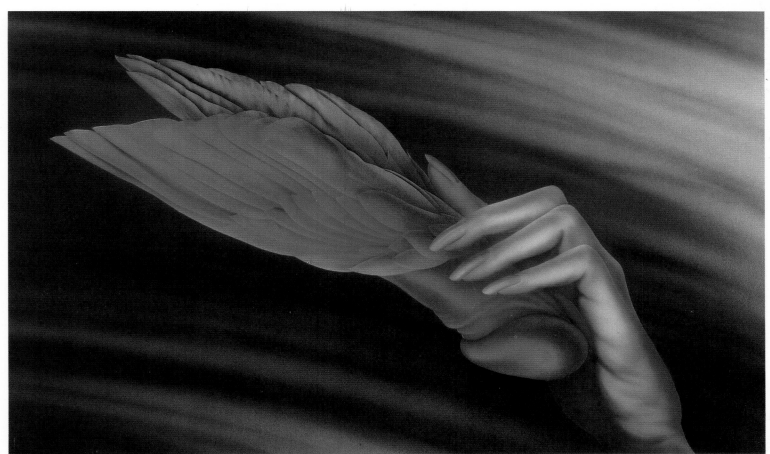

Bill Imhoff

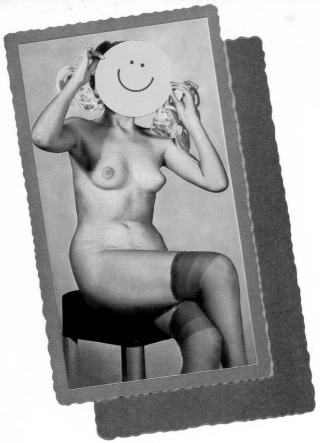

Grin and Bare It · *Ken Kneitel*

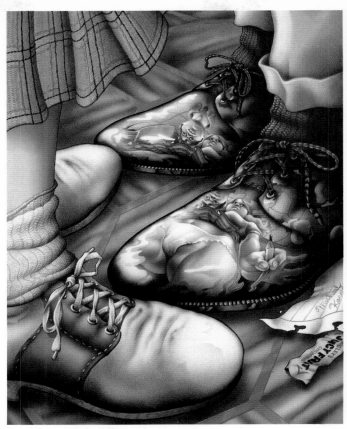

Skool Daze · *Michael Kanarek*

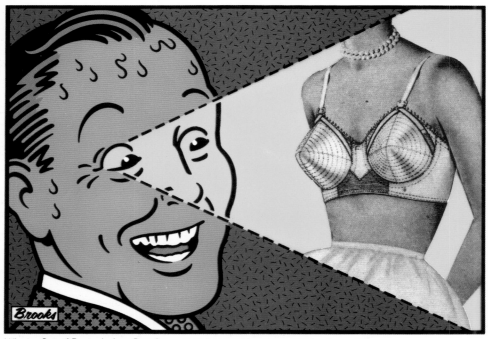

What a Set of Brains! · *Lou Brooks*

Blind Date · *Paul Reott* ▶

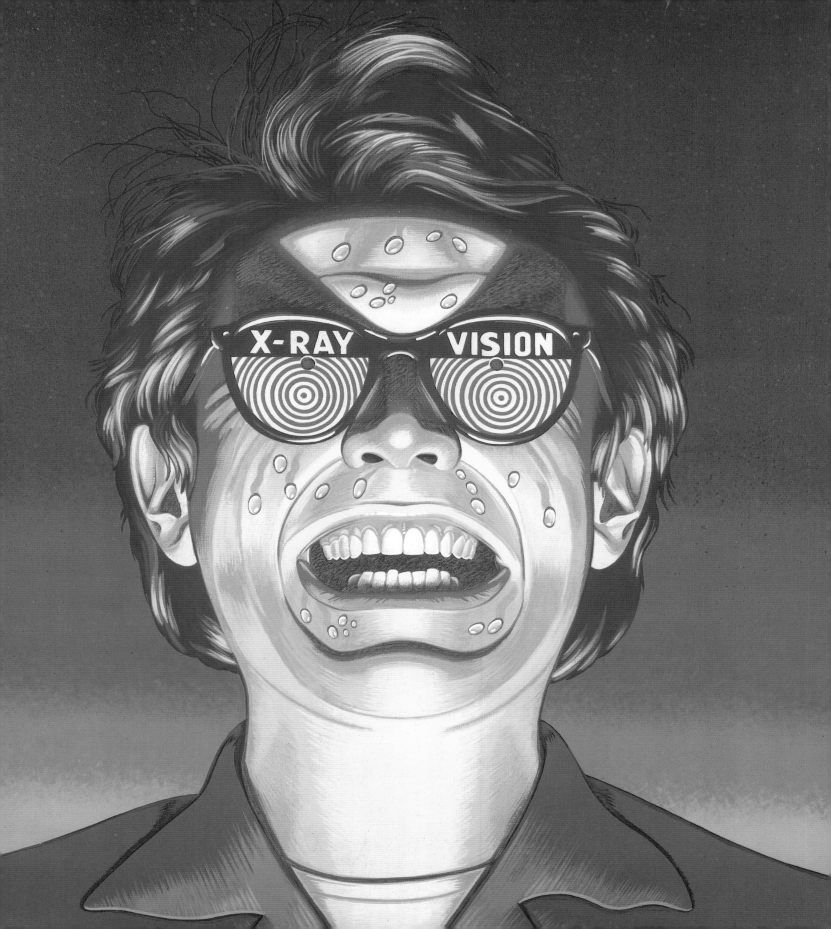

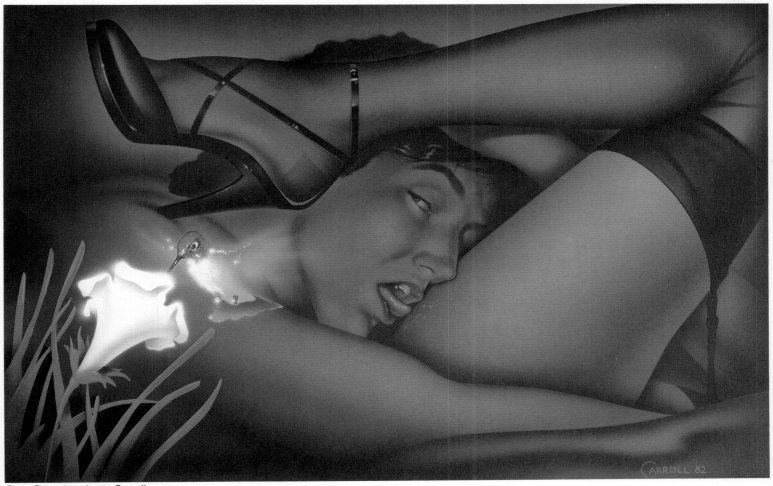

Clam Chowder · *Justin Carroll*

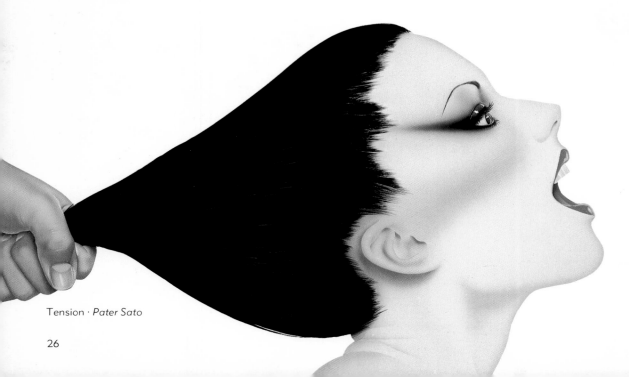

Tension · *Pater Sato*

26

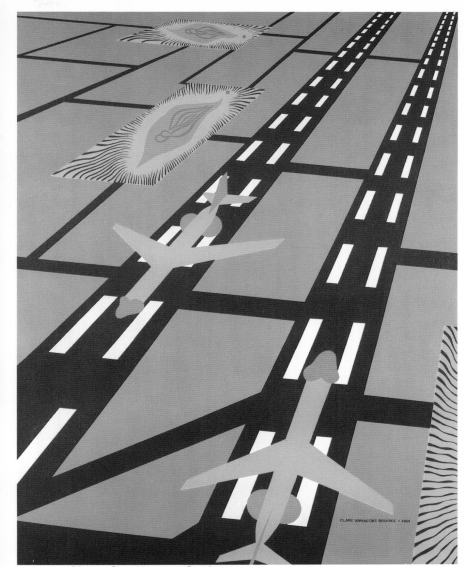

Landing at O'Hair · *Clare Vanacore Brooks*

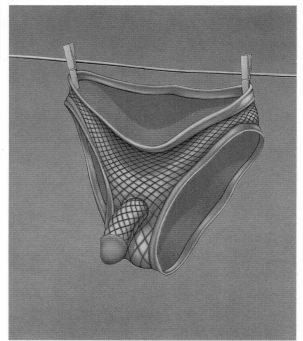

Norman Catherine

Up Fido! · *Everett Peck*

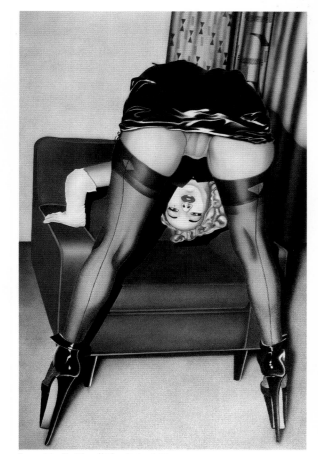

From Me To You #10 • *Robert Blue*

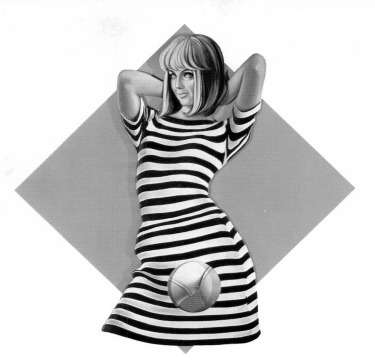

Beaver Shot · *Mel Ramos 1966*

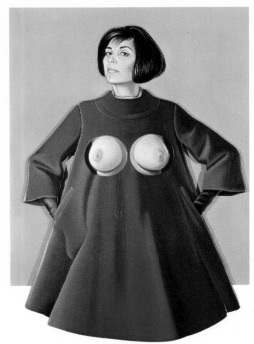

Blue Coat · *Mel Ramos 1966*

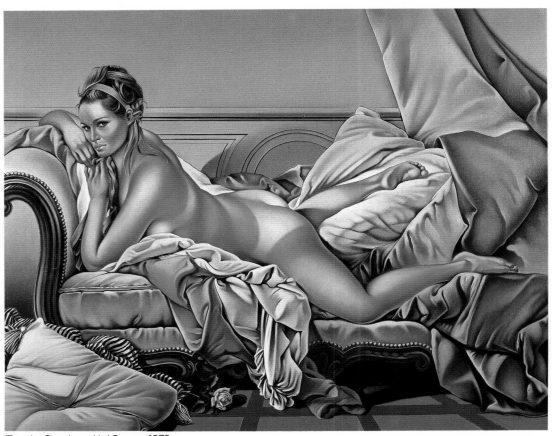

Touche Boucher · *Mel Ramos 1973*

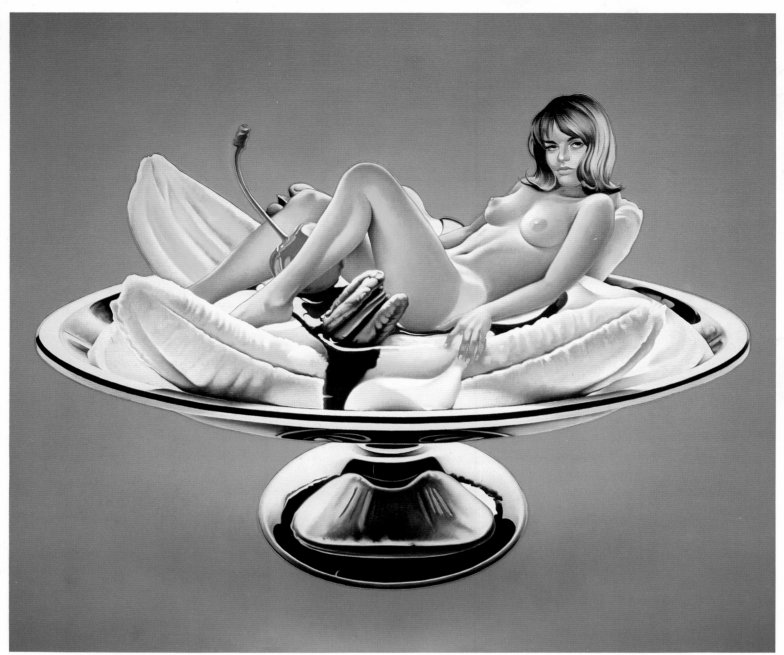

Banana Split · *Mel Ramos 1970*

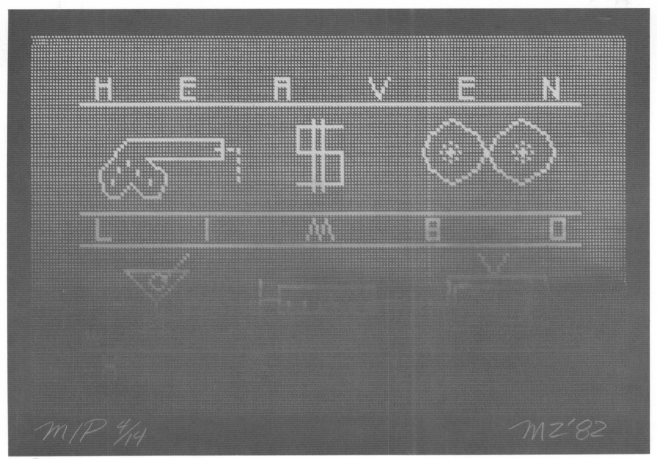

May Zone

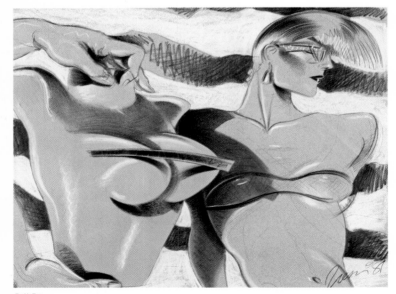

Bill Rieser

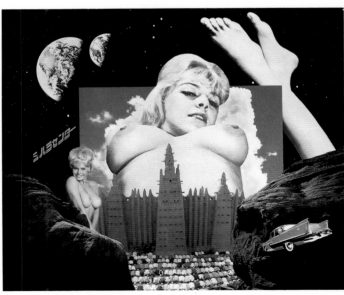

Worshipers of the Orb · *David Peters*

Seymour Cone · *David McMacken* ▶

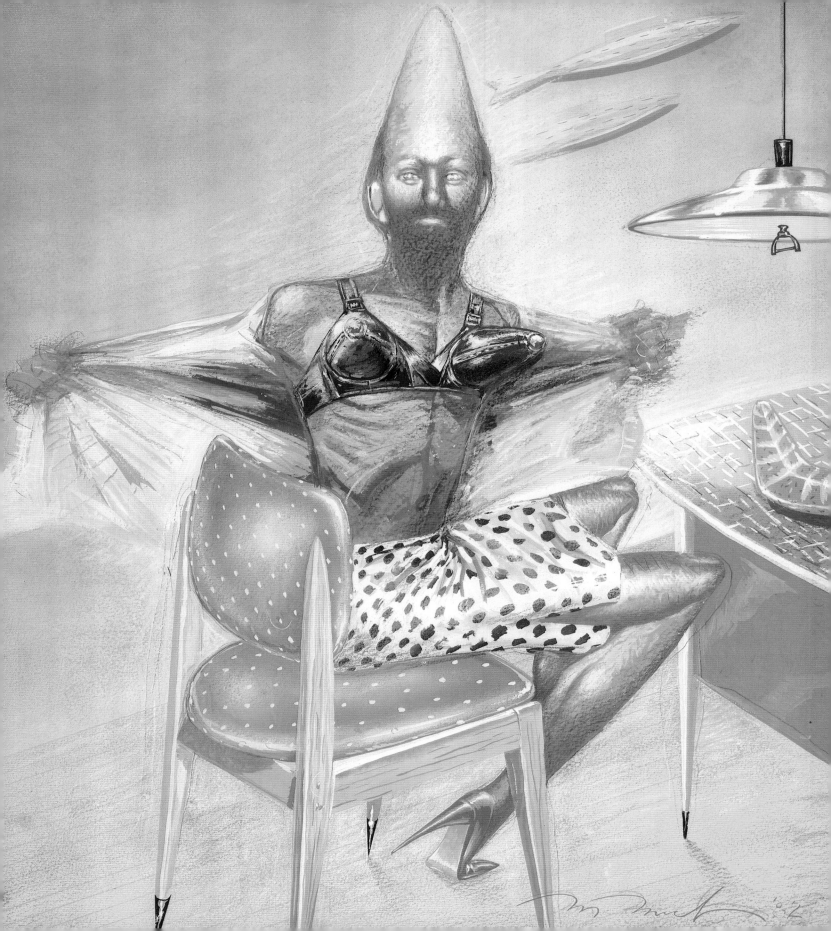

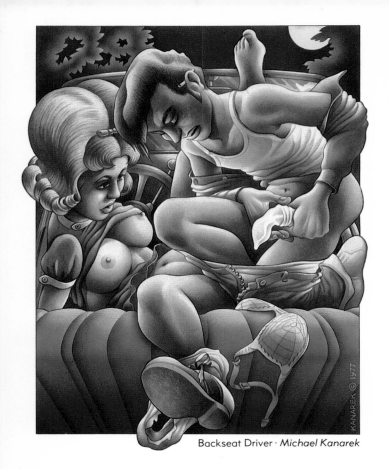

Backseat Driver · *Michael Kanarek*

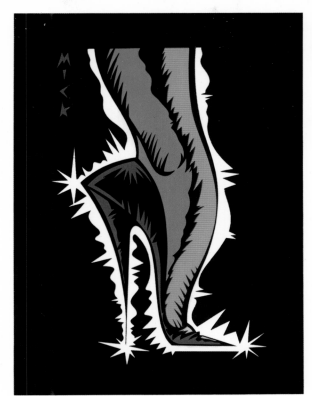

Shoo! · *Mick Haggerty '76*

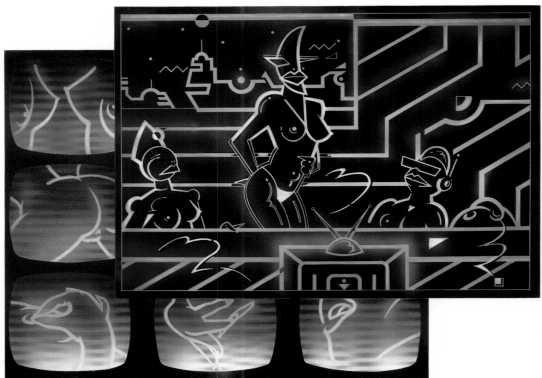

Video Feedback · *Montxo Algora*

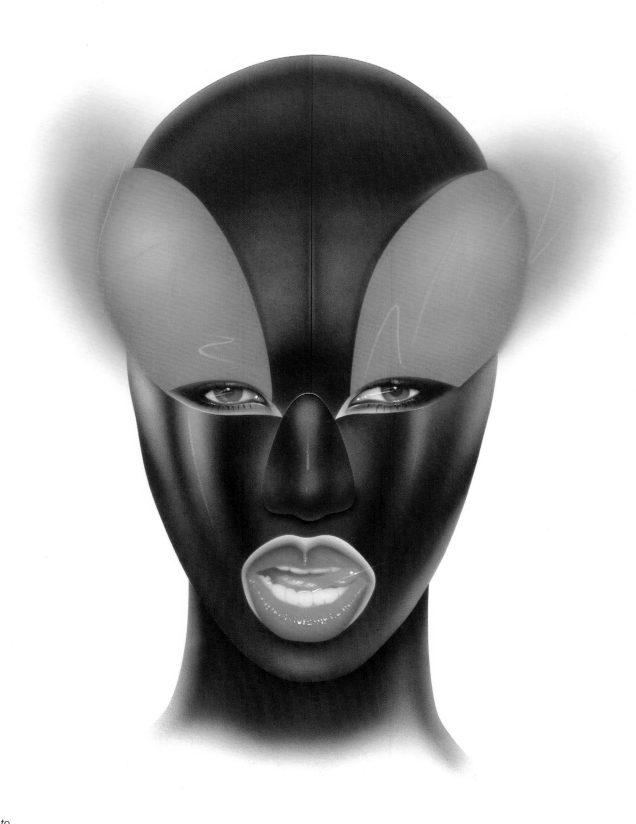

Mask · *Pater Sato*

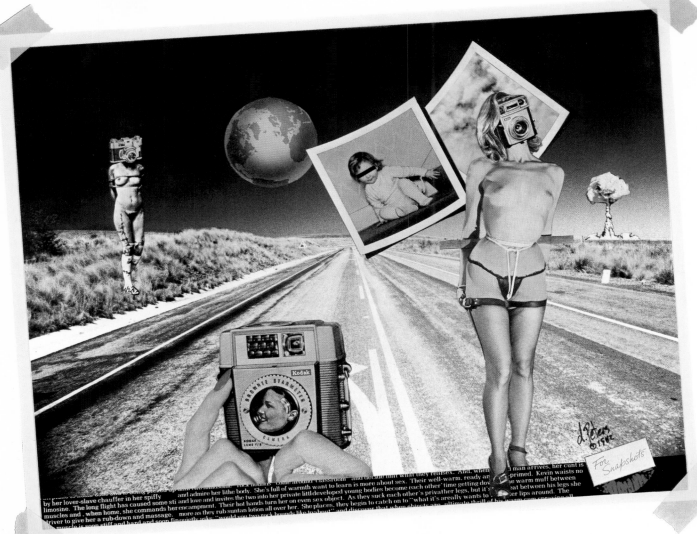

First Loves · *David Peters*

Möbius Strip · *Stephanie Lipney Farago*

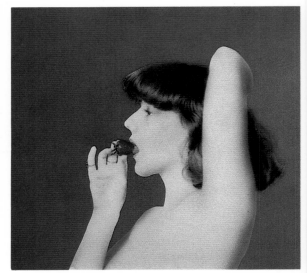

Lick It! · *Helen Vita*

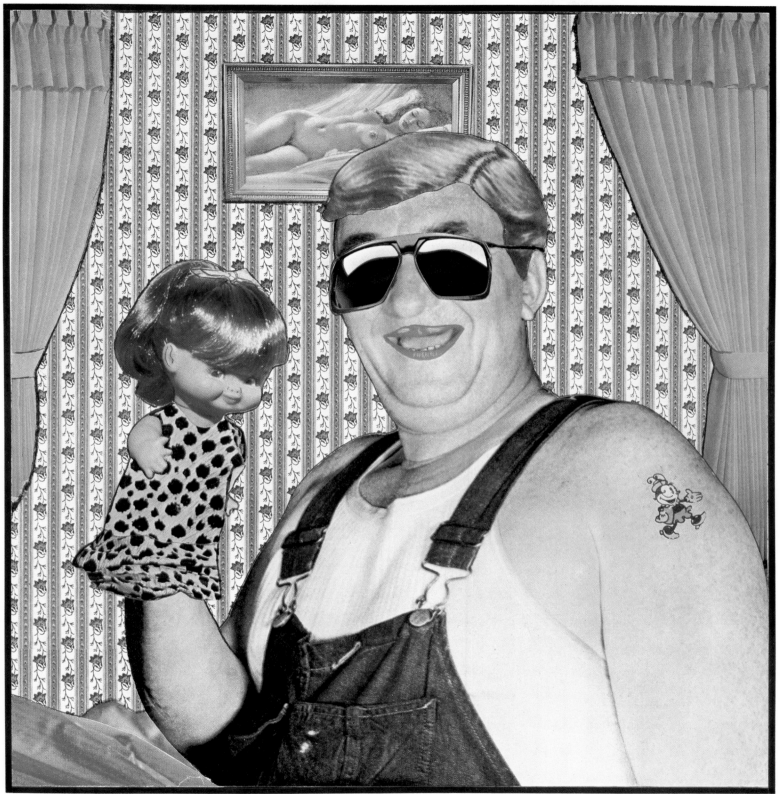

Bob · *Lou Beach*

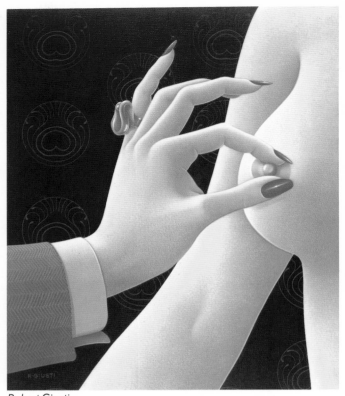

Robert Giusti

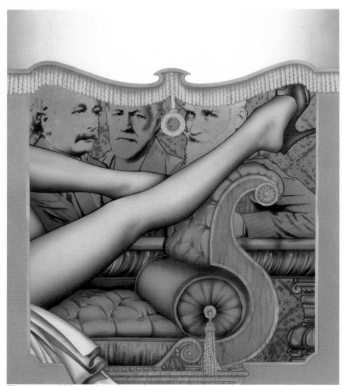

Thinking of You · Ann Meisel

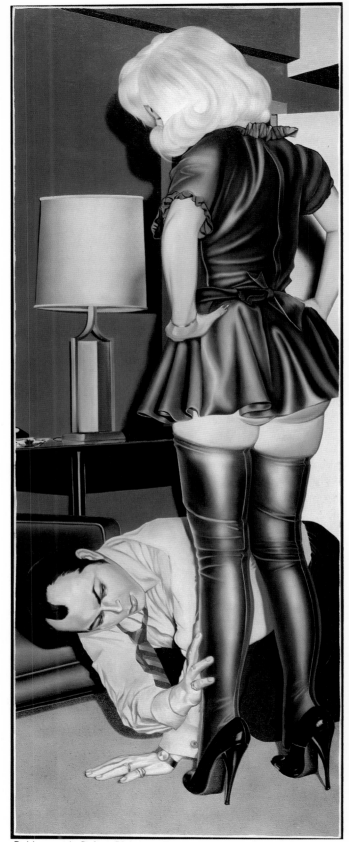

Rubbermaid · Robert Blue

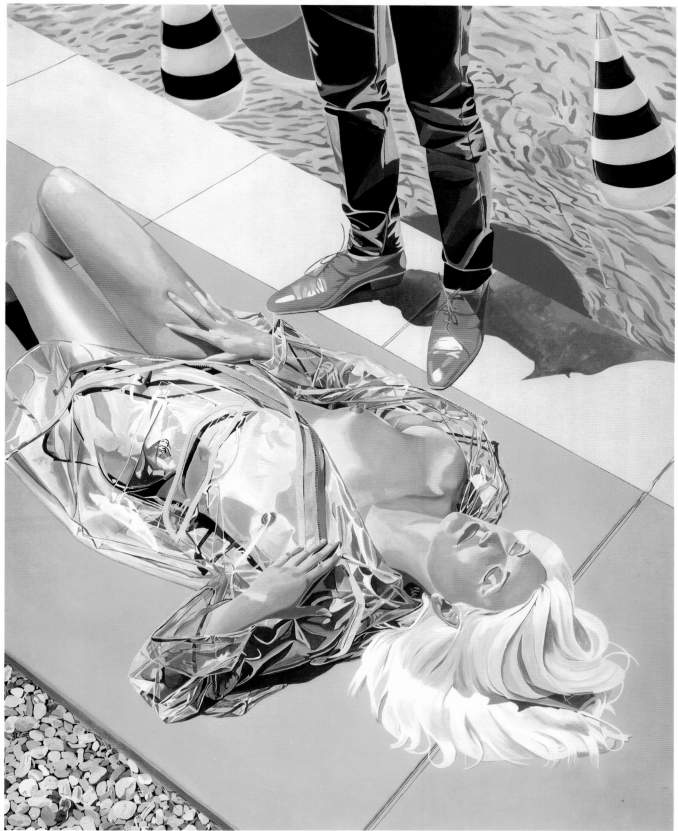

Gregory and Gisele/So. Cal. Pool Scene · *Nick Taggart*

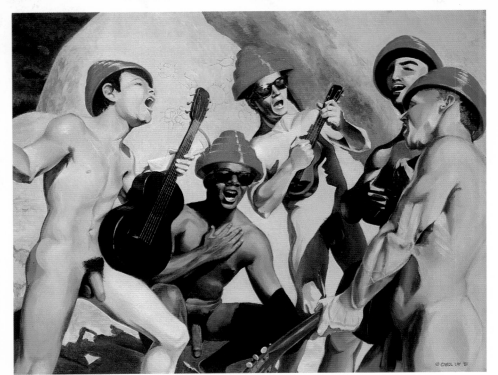

Are We Not Men? · *Carol Lay*

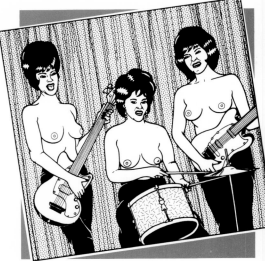

The Jug Band at the Road House · *Ron Lieberman*

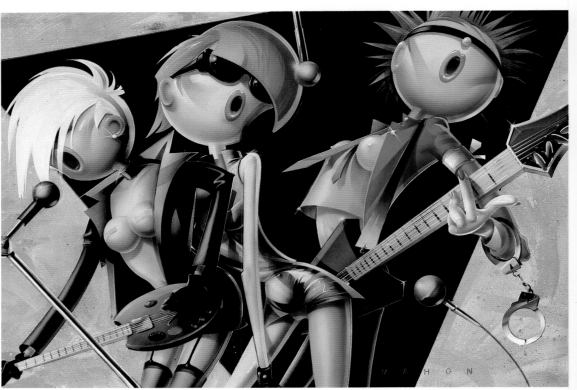

Be, Bop, and Lula · *Rich Mahon*

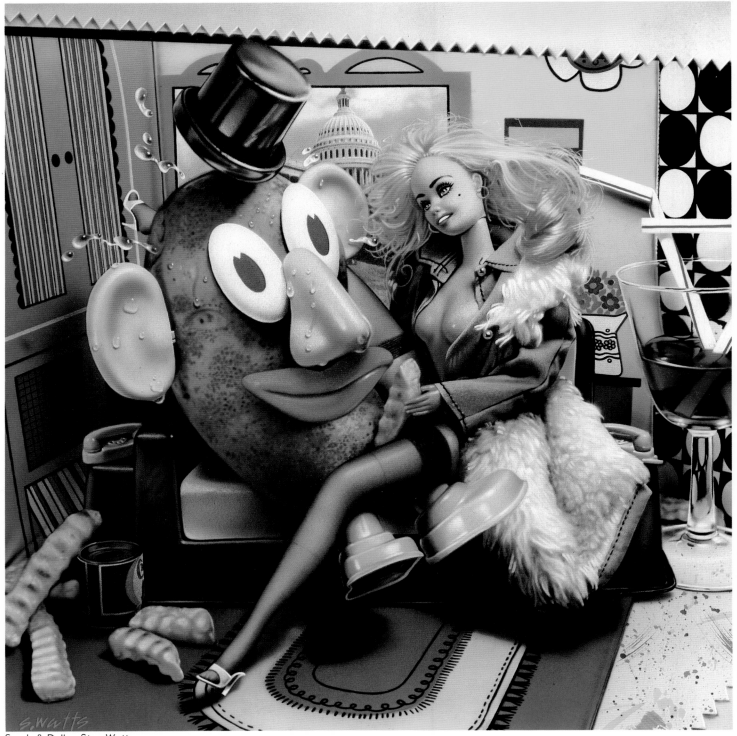

Spuds & Dolls · *Stan Watts*

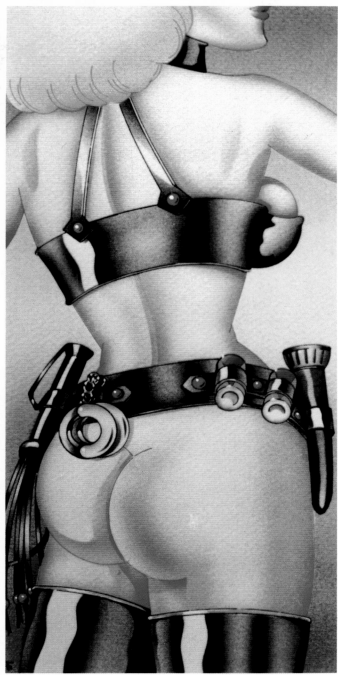

Batteries Included · *Francois Robert*

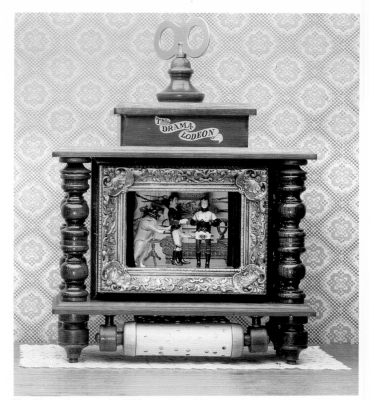

The Dramalodeon · *Jim Wilson*

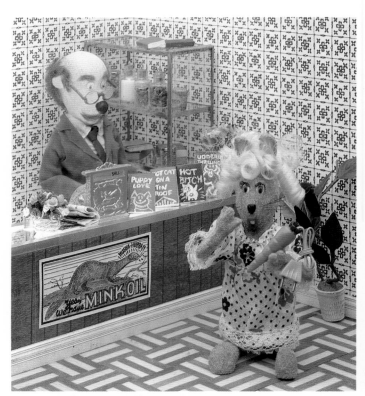

The Electric Carrot · *Jim Wilson*

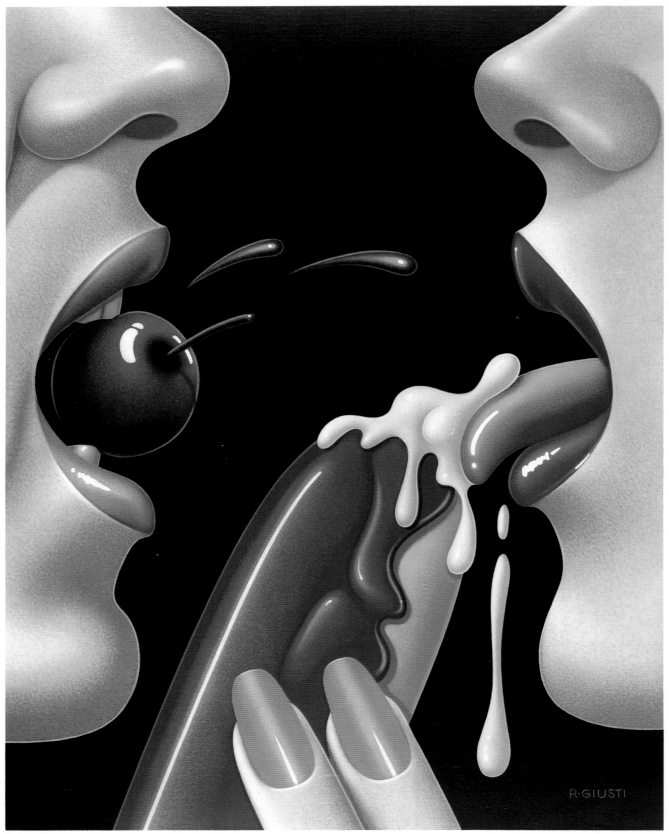

Robert Giusti

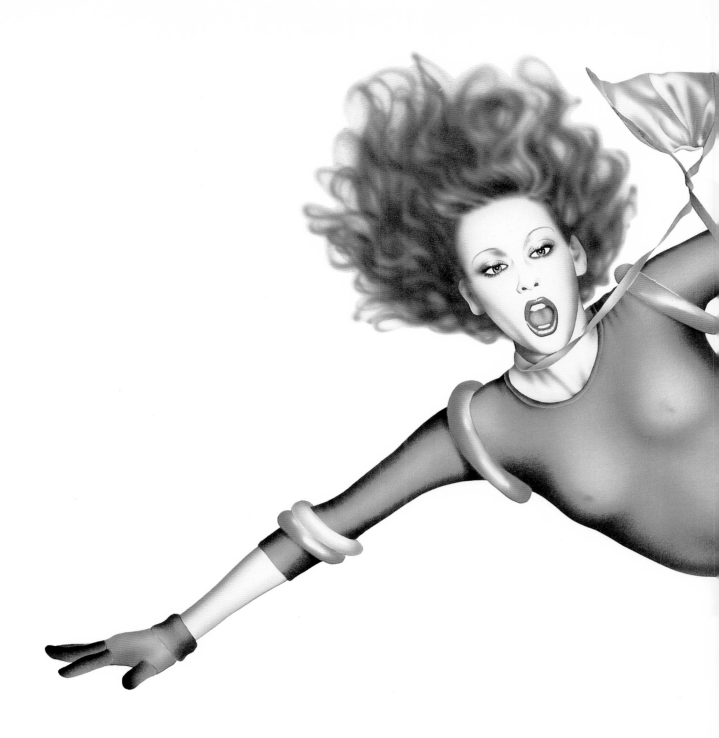

Spread Eagle · *Harumi Yamaguchi*

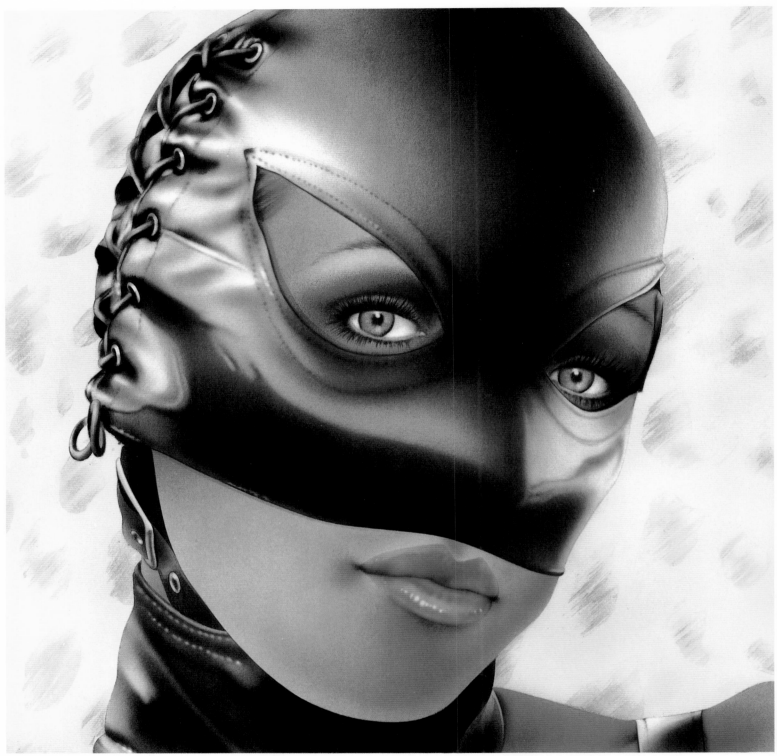

Leatherlady #1 · *Brian Zick*

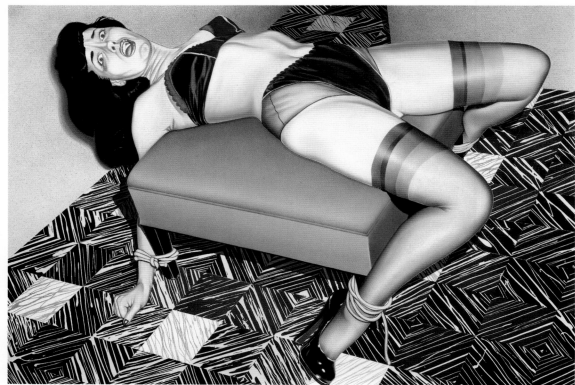

Betty Page in Bondage #2 · *Robert Blue*

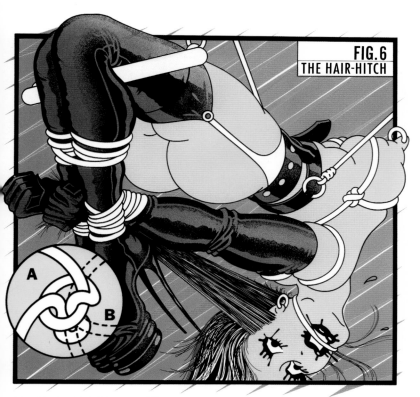

FIG.6
THE HAIR-HITCH

Hair Hitch · *Mick Haggerty '75*

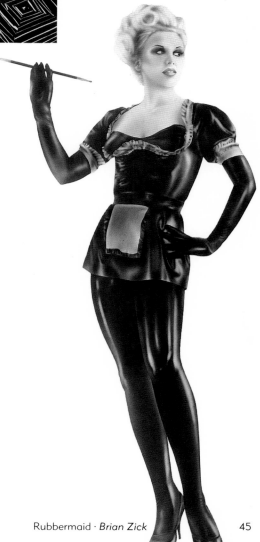

Rubbermaid · *Brian Zick*

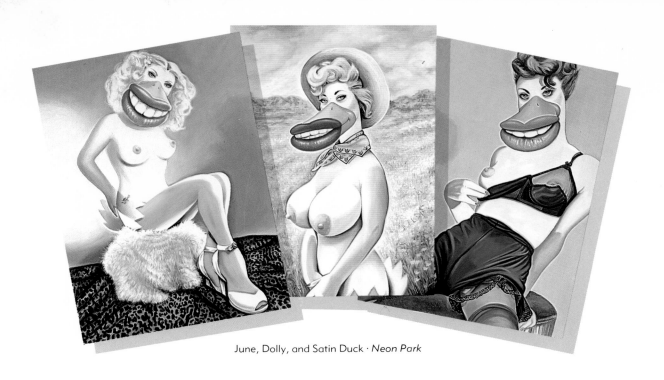

June, Dolly, and Satin Duck · *Neon Park*

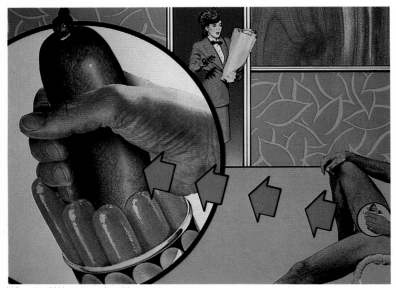

Whackin' Weenies · *Jim Heimann*

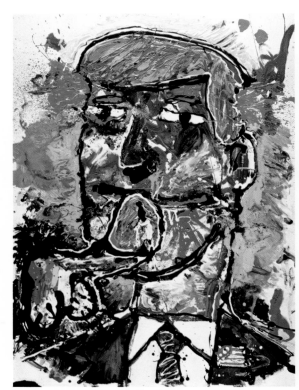

Title **Not** Acceptable · *Jay Condom*

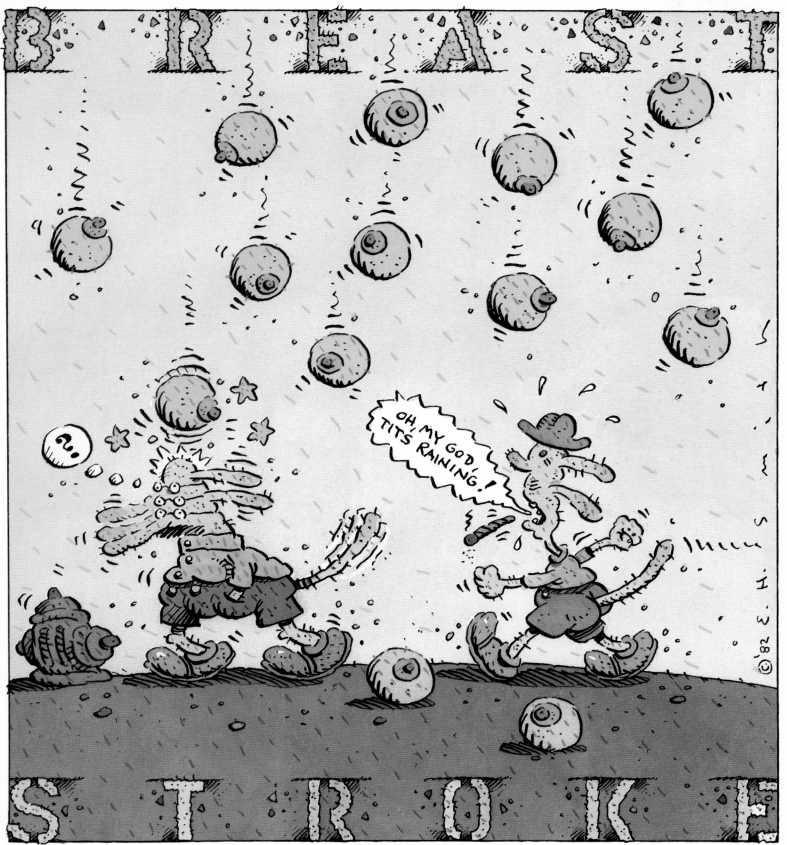

Breast Stroke · *Elwood H. Smith*

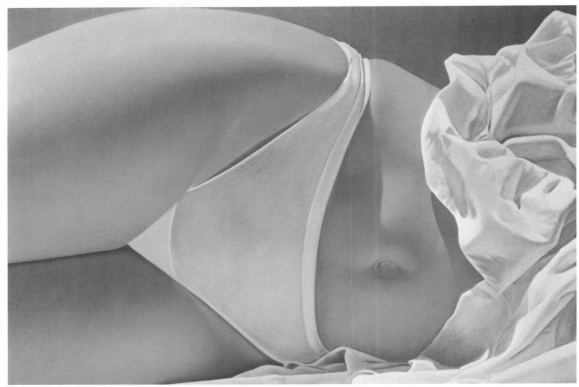

White Panties: White Slip (Front View) · *John Kacere 1971*

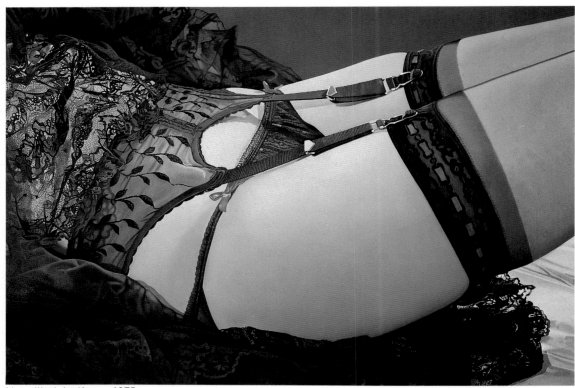

Maija III · *John Kacere 1975*

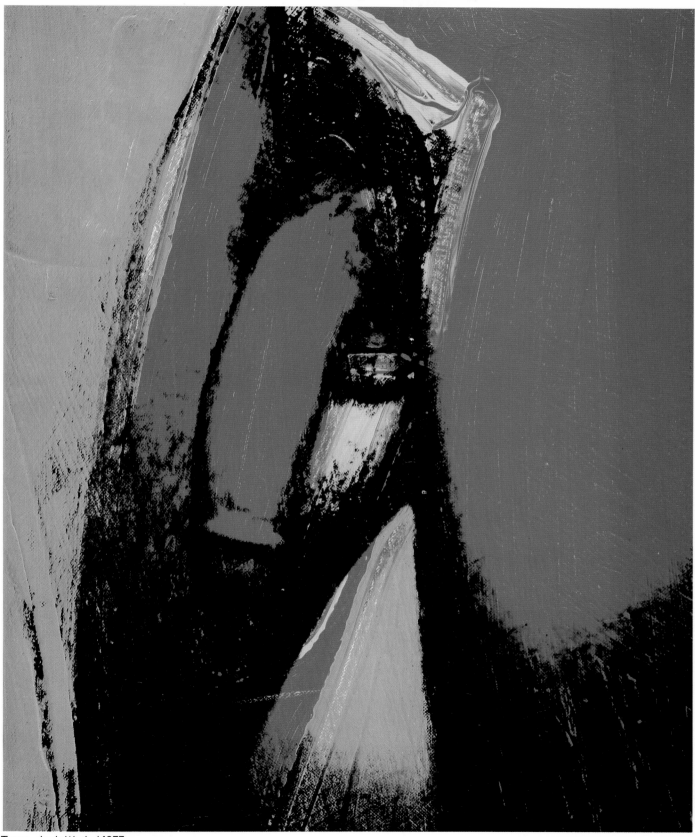

Torso · Andy Warhol 1977

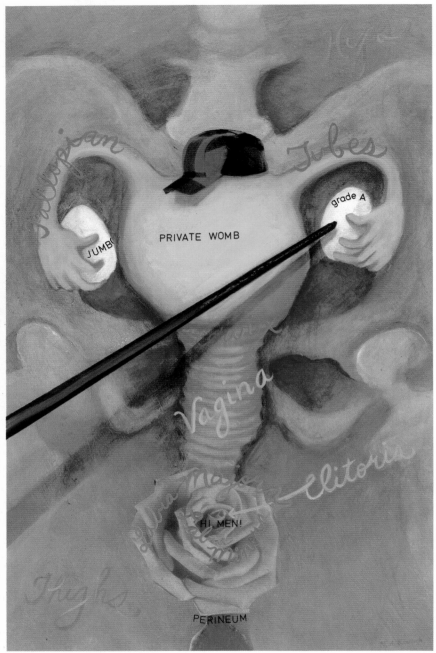

An Exercise in Fertility · *Nancy Kintisch*

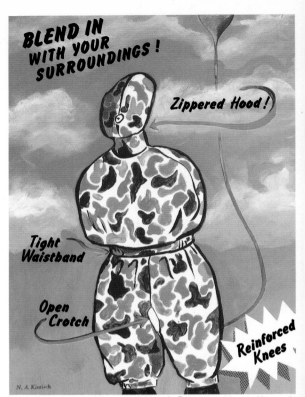

With Friends Like You, Who Needs Enemas · *Nancy Kintisch*

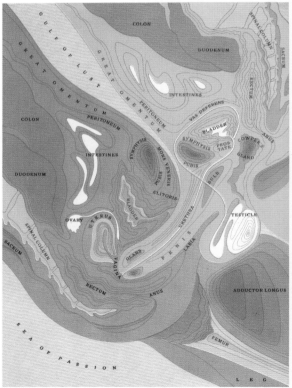

Coitus Topographicus · *Liz Gutowski*

Rubberlady of the Tropicana · *Neon Park* ▶

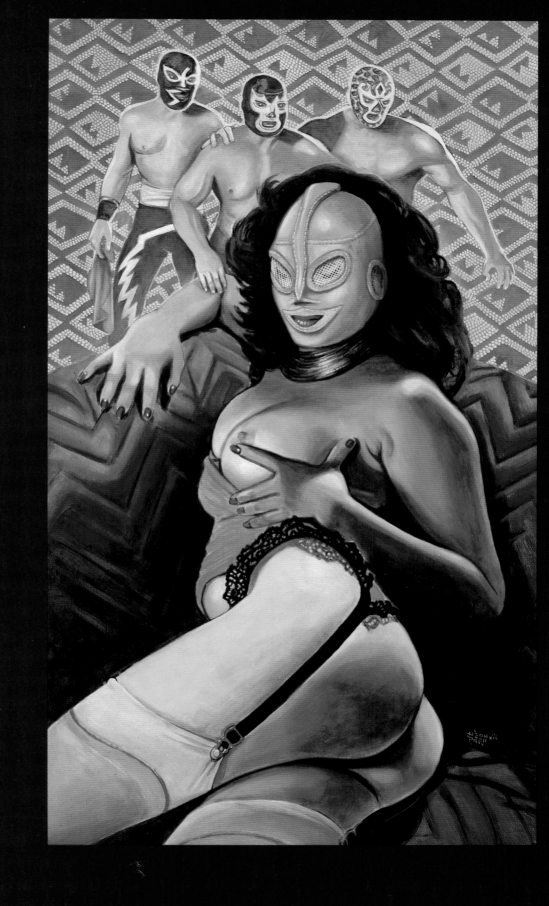

Erotech Glutius Minamus · Zox

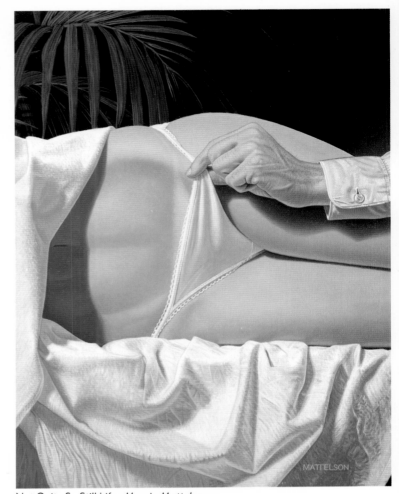

Not Quite So Still Life · *Marvin Mattelson*

Behind · *Katsu*

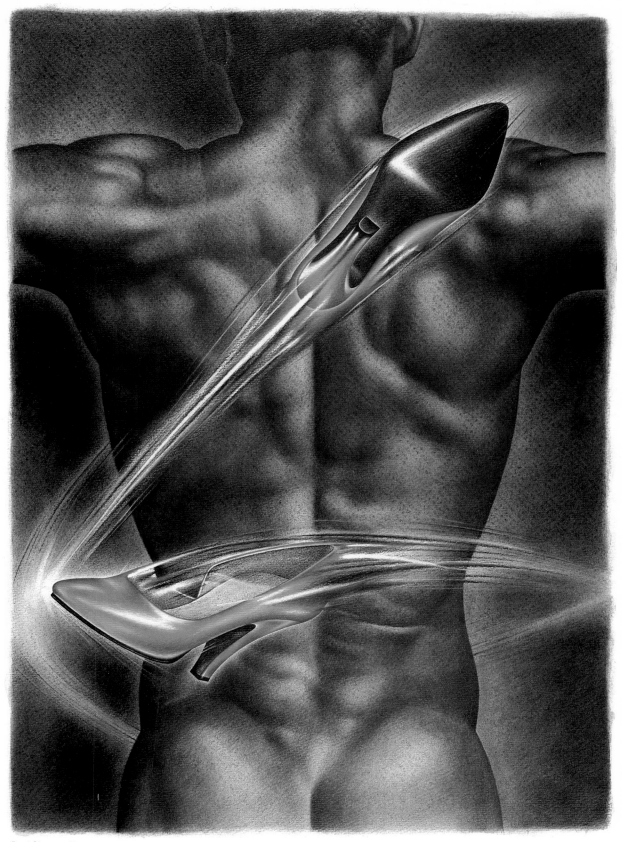

Red Shoes · *Katsu*

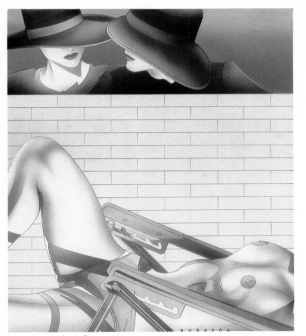

Voyeurs · Mark Busacca

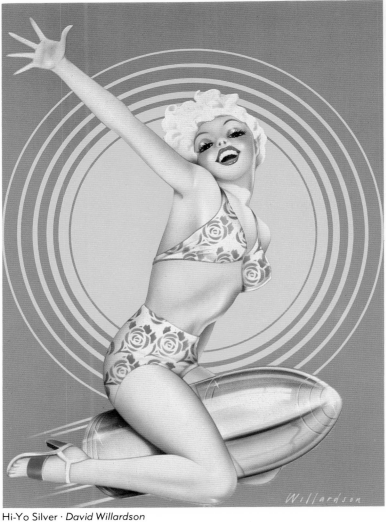

Hi-Yo Silver · David Willardson

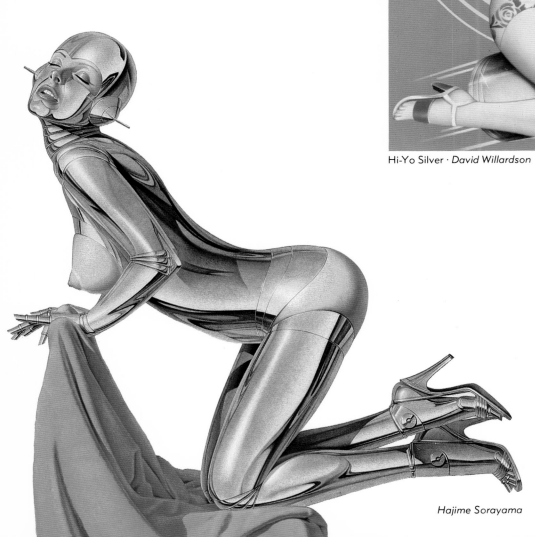

Hajime Sorayama

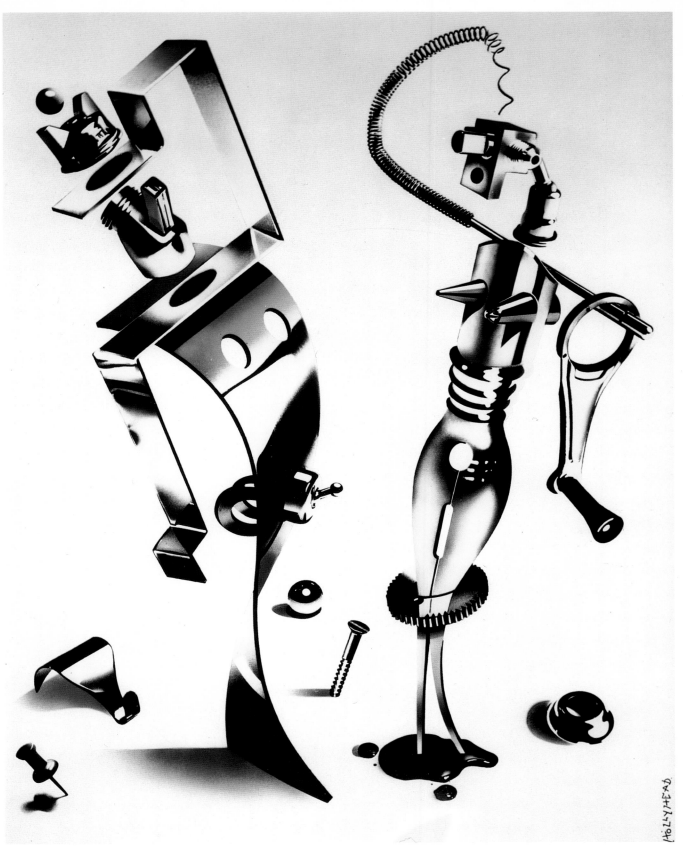

Turn On · *Bush Hollyhead*

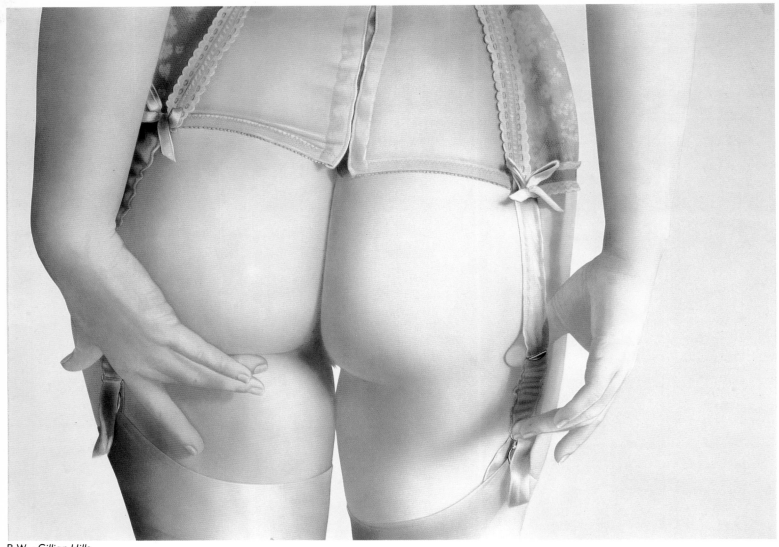

B.W. · Gillian Hills

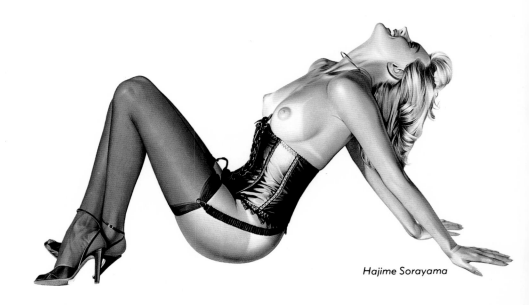

Hajime Sorayama

56

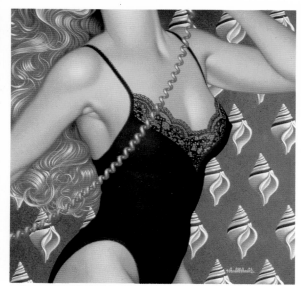

Call Girl • *Braldt Bralds*

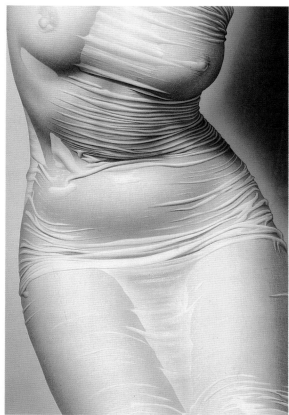

Torso · *Yosuke Ohnishi*

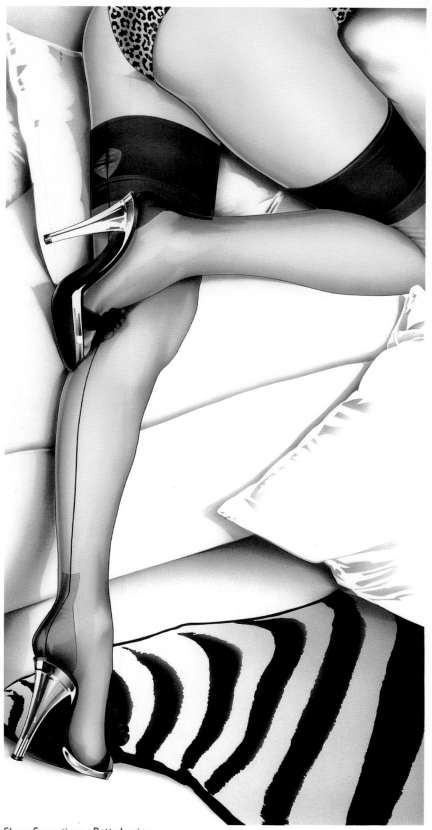

Sheer Sensations · *Bette Levine*

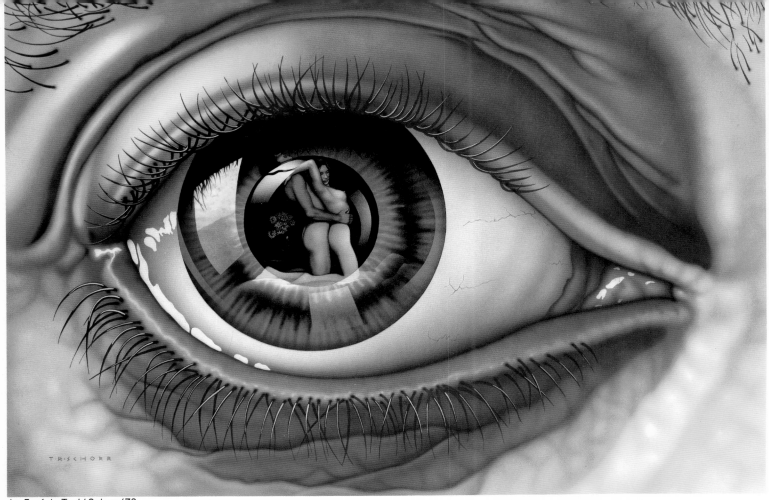

An Eyeful · *Todd Schorr '78*

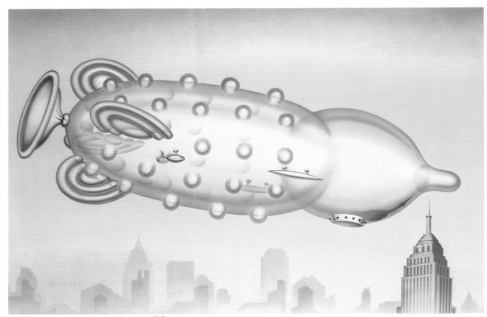

Goodrear Blimp · *Todd Schorr '78*

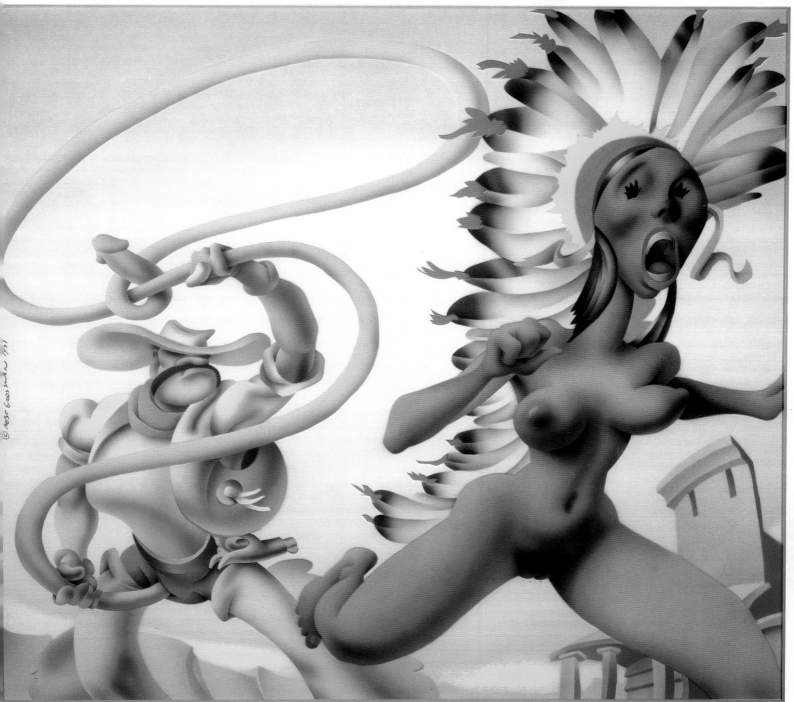

How the West Was Won · Robert Grossman

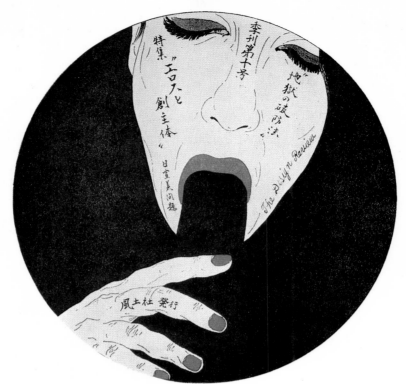

Tadanori Yokoo 1969

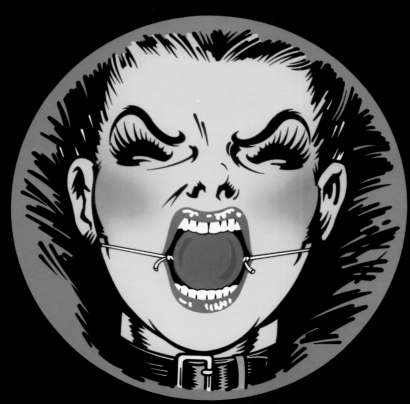

Lou Brooks

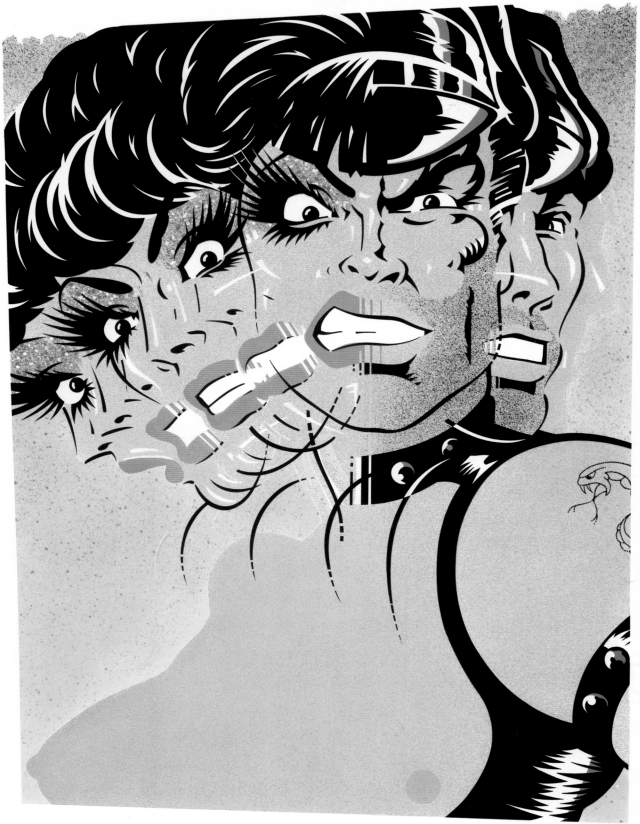

Cycleslut · *Mick Haggerty '77*

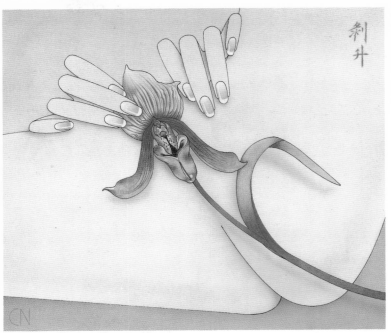

Fragrance of Love · *Christine Nasser*

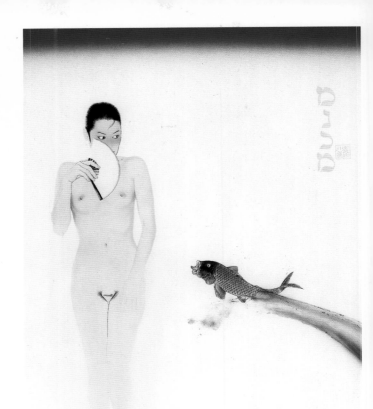

White Man's Dilemma · *Bill Tom/Mark Hanauer*

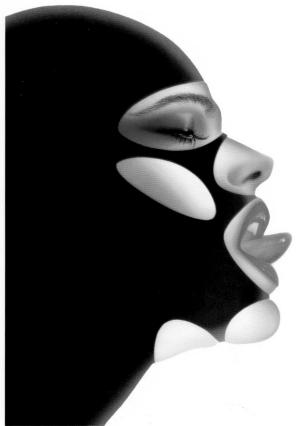

Devil's Shoes · *Pater Sato*

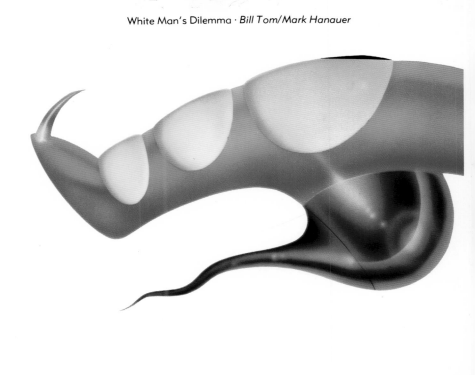

62

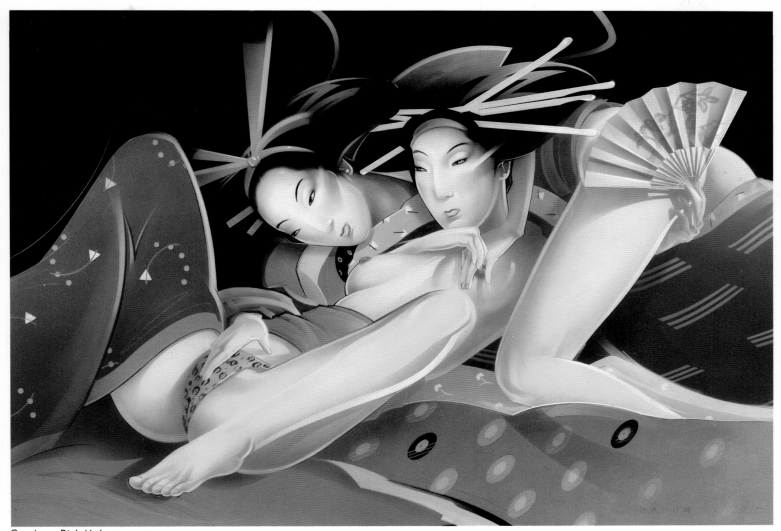

Gayshas · *Rich Mahon*

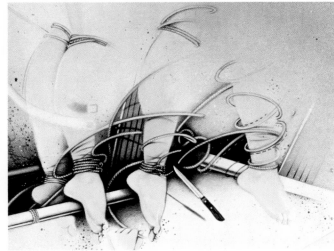

Sex Bonds · *Dave Calver*

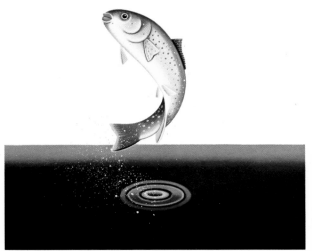

Fish Lips · *Dave Calver*

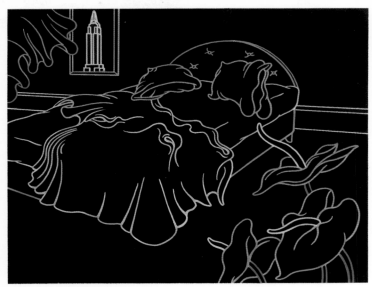

Exposed · *Ron Lieberman*

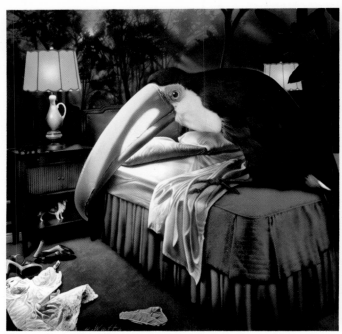

Toucan Do It · *Stan Watts*

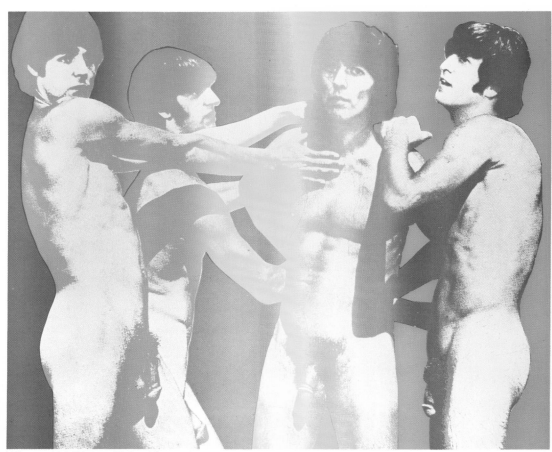

I Want to Hold Your... *Richard Bernstein*

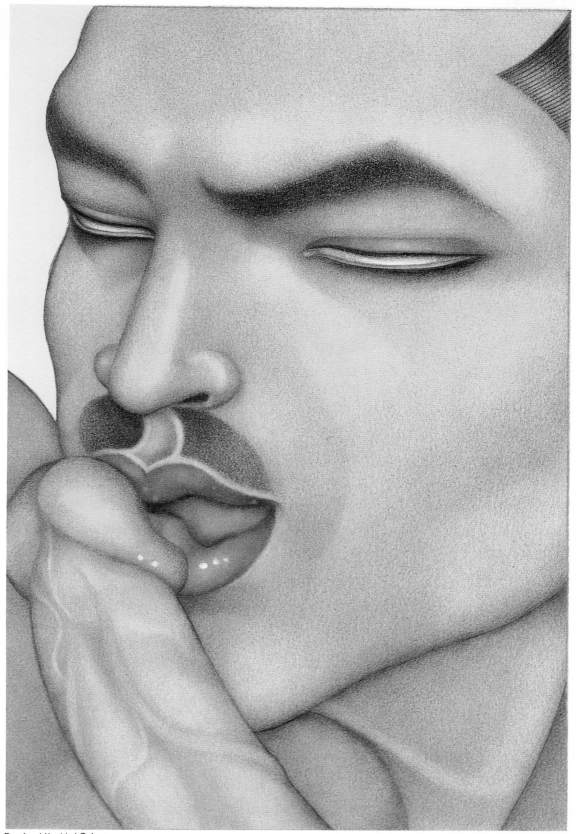

Rayford II · *Mel Odom*

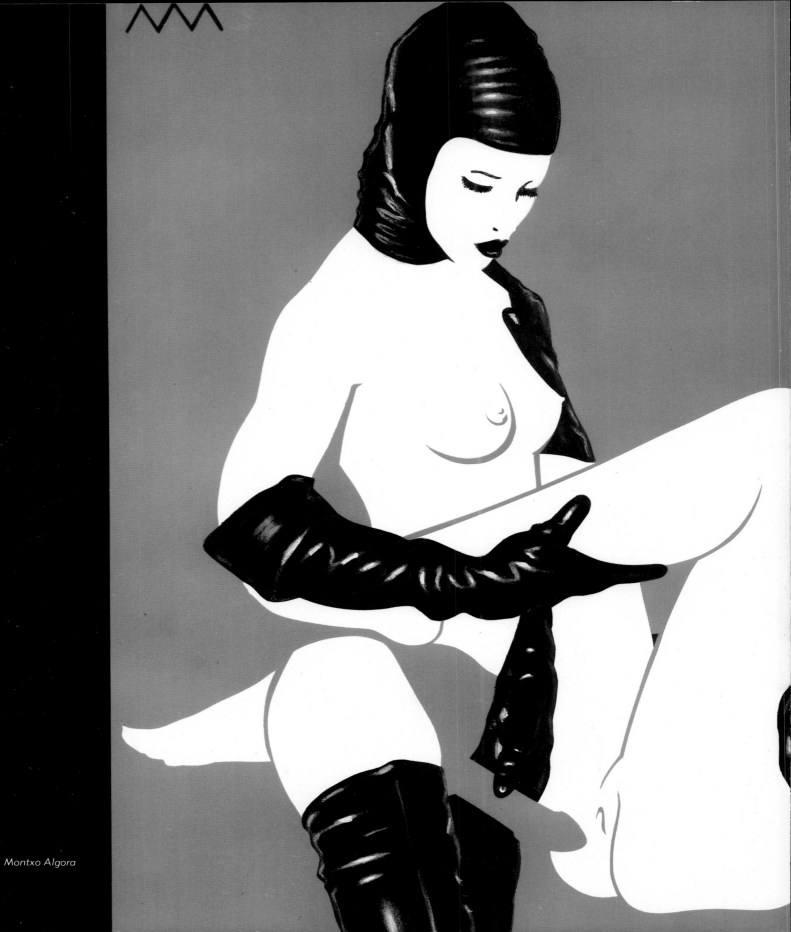

Montxo Algora

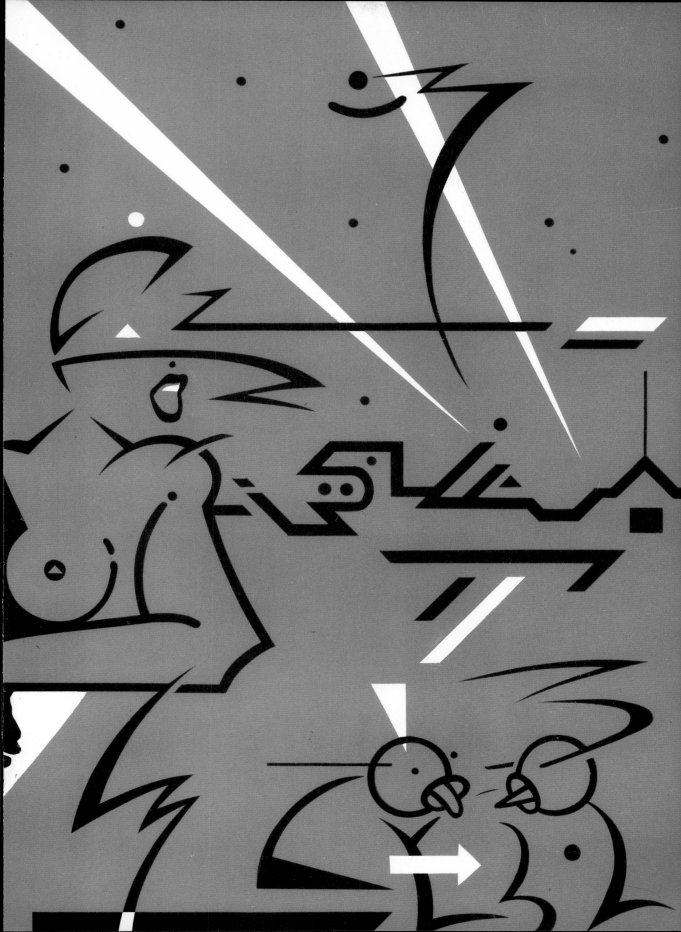

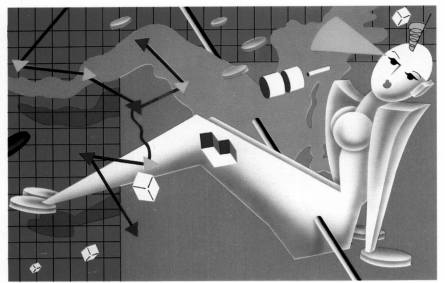

In Dreams · *Iku Akiyama*

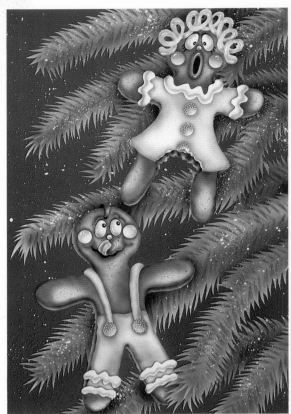

A Piece of Gingerbread · *Sharon Harker*

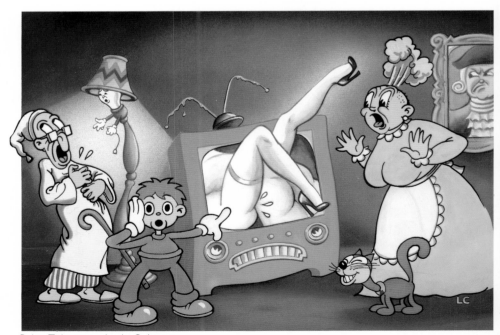

Pubic Television · *Leslie Cabarga*

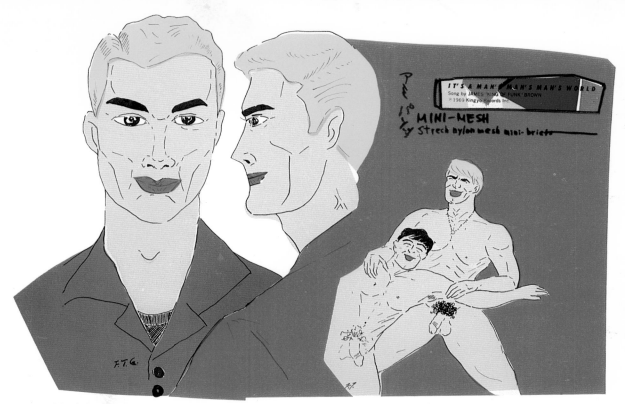

Man's World · Terry-Man Yumura

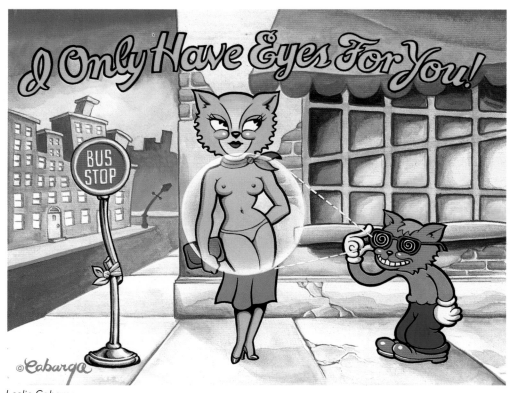

Leslie Cabarga

Olivia de Berardinis

Caddy · Brian Zick

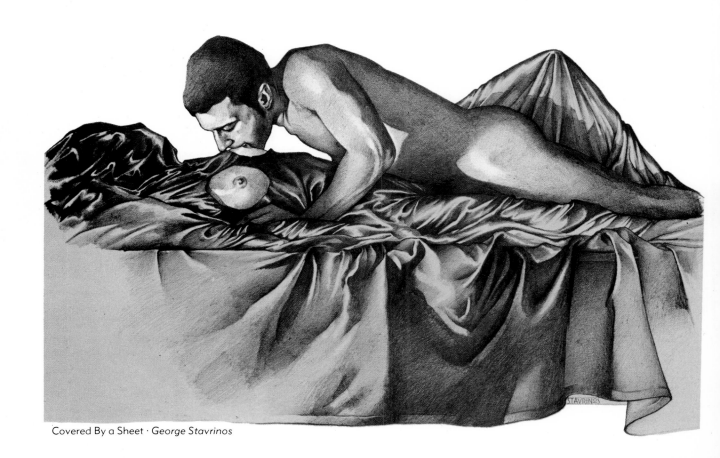

Covered By a Sheet · George Stavrinos

70

Latex Lucy · *Dennis Mukai*

The Golden Fleece · *John Lykes*

69% Fewer Cavities · *Todd Schorr '76*

Otto · *Pearl Beach*

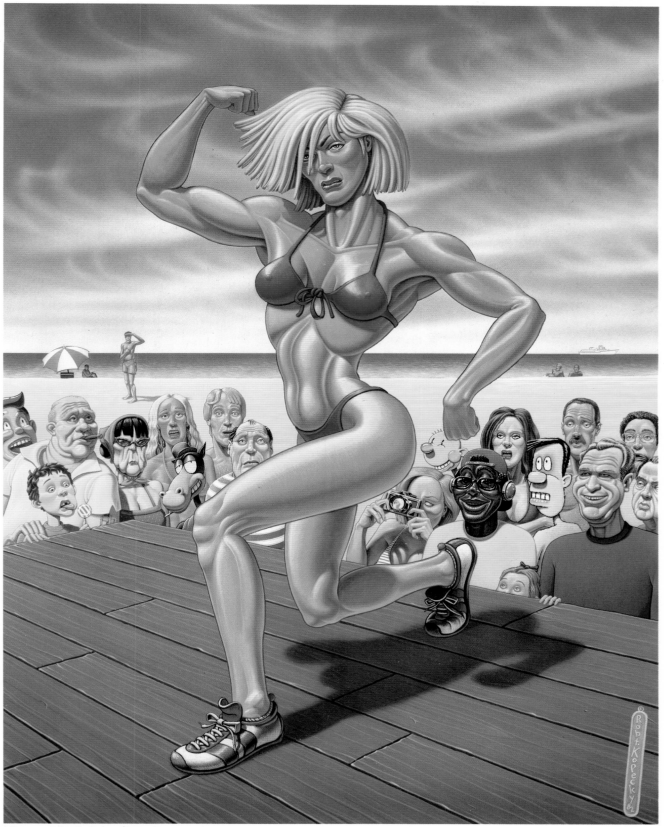

Woman of Steel · *Robert Kopecky*

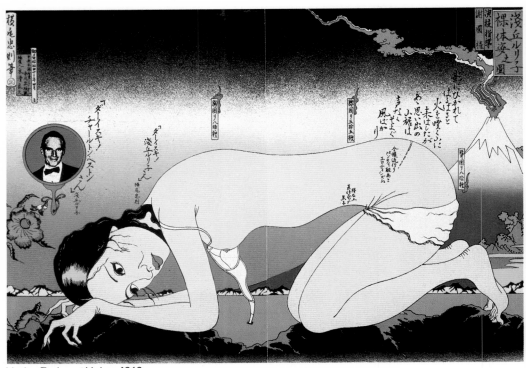

Nude · *Tadanori Yokoo 1969*

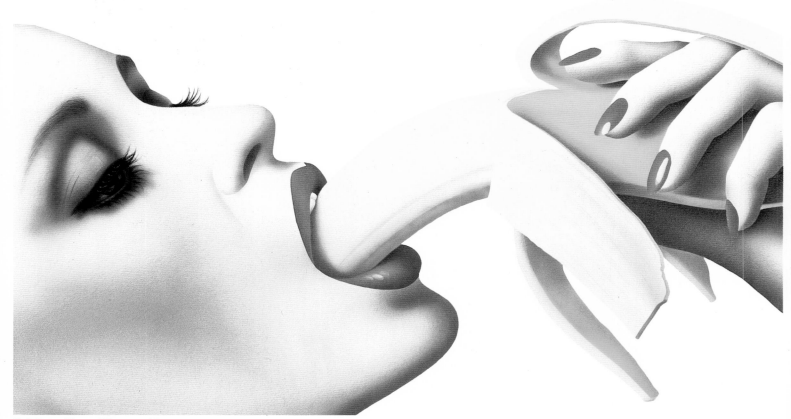

Delicious · *Harumi Yamaguchi*

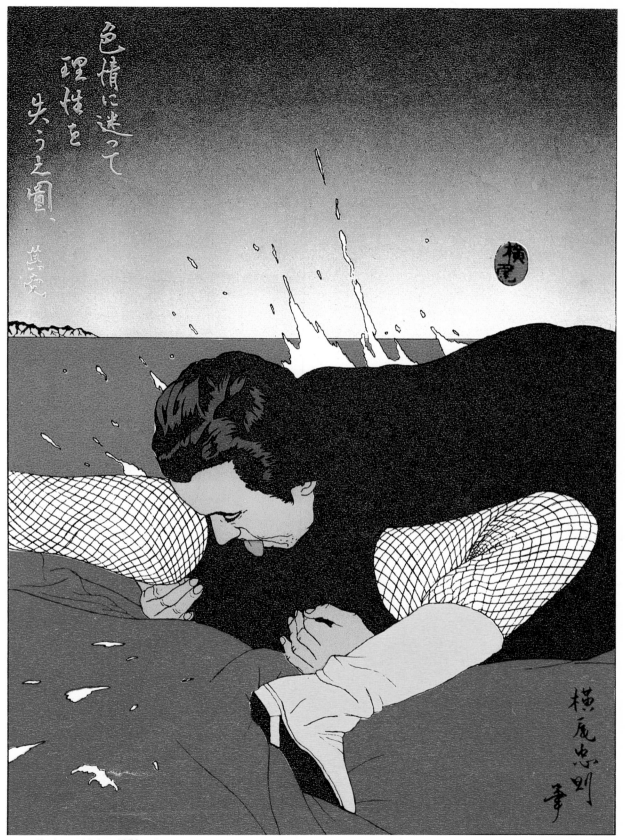

色情に迷って
理性を
失うの圖、
其愛、

Rape · *Tadanori Yokoo 1970*

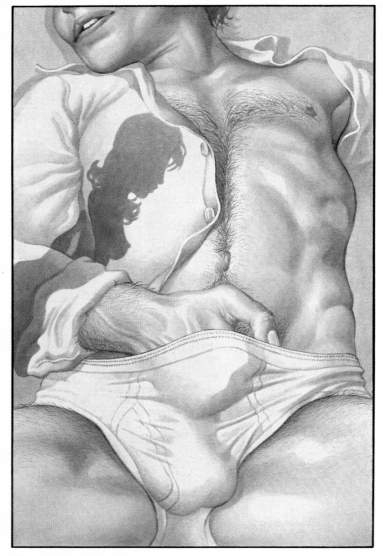

Cheap Date · *Michael Kanarek*

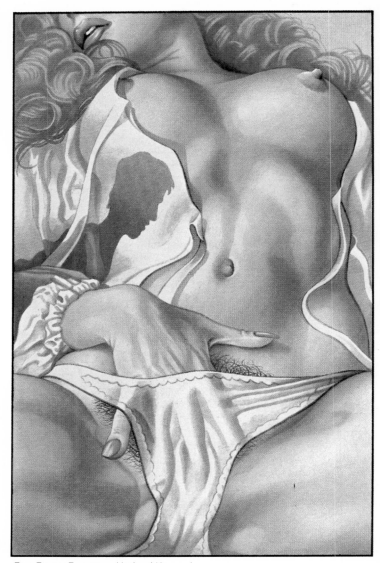

Five Finger Exercise · *Michael Kanarek*

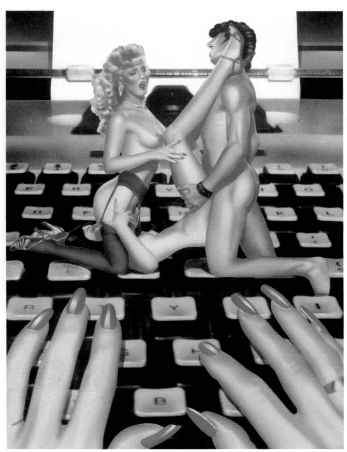

I Am A Female Smut Writer · *Dale Sizer*

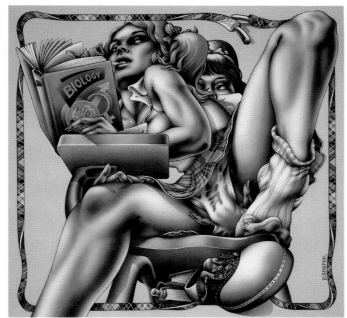

The Biology Lesson · *Michael Kanarek*

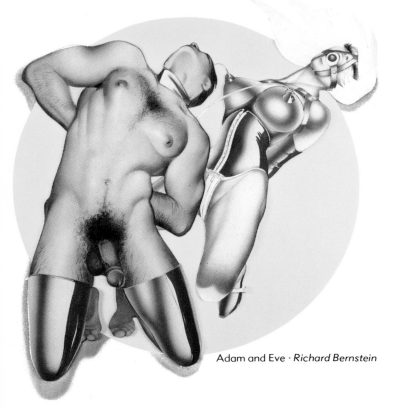

Adam and Eve · *Richard Bernstein*

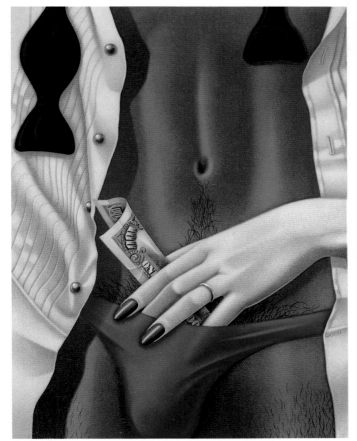

Robert Giusti

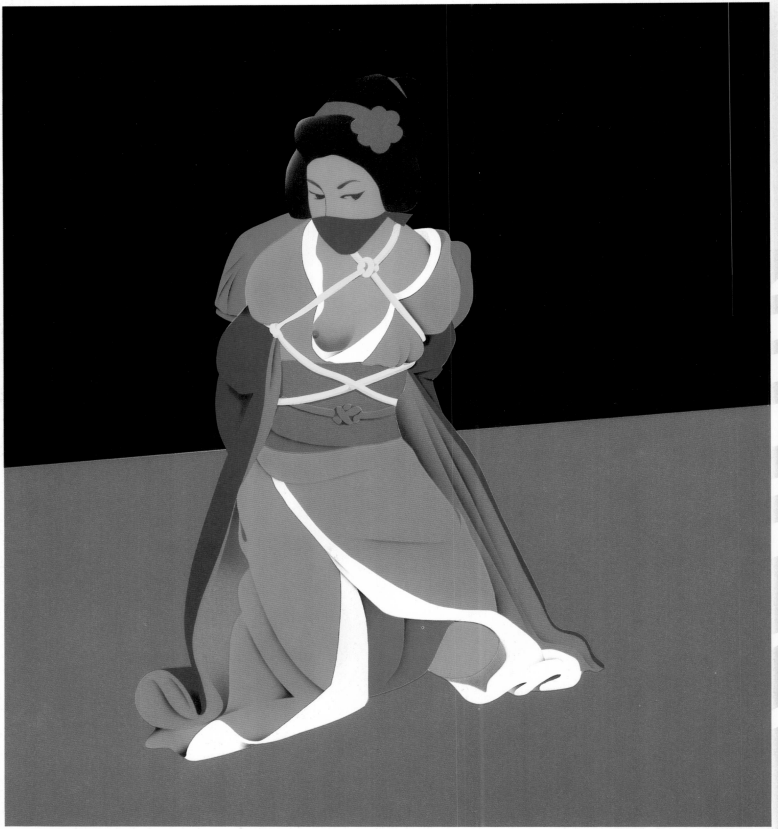

Maiden America · *Vartan*

Bump Your Booty · *John Van Hamersveld* ▶

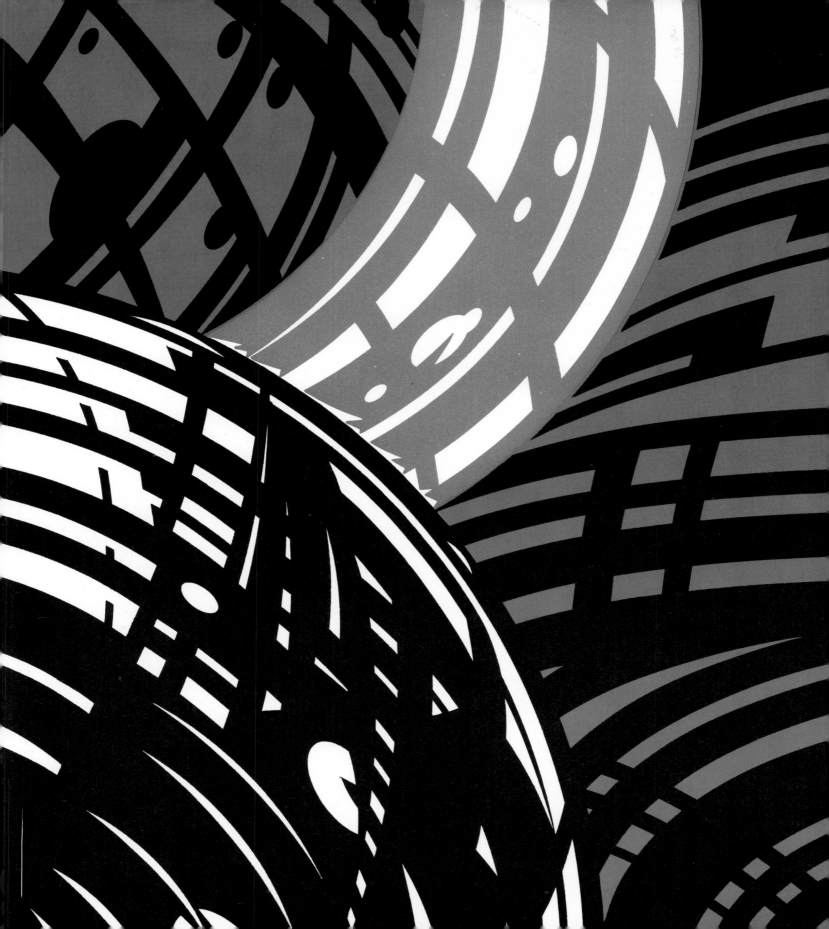

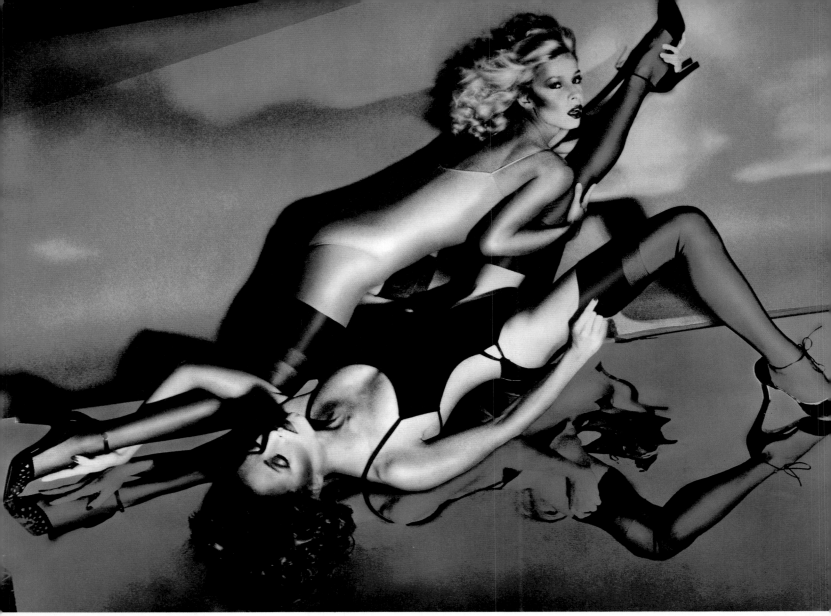

Silk Stockings · *Lisa Powers/Taki Ono*

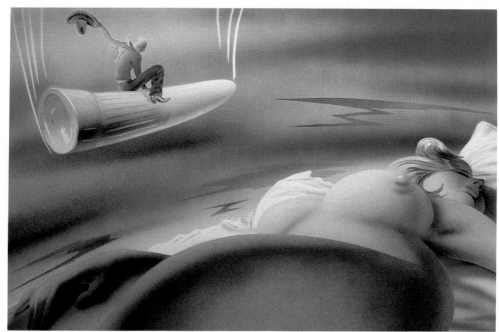

How I Learned To Stop Worrying and Love the Vibrator · *Robert Grossman*

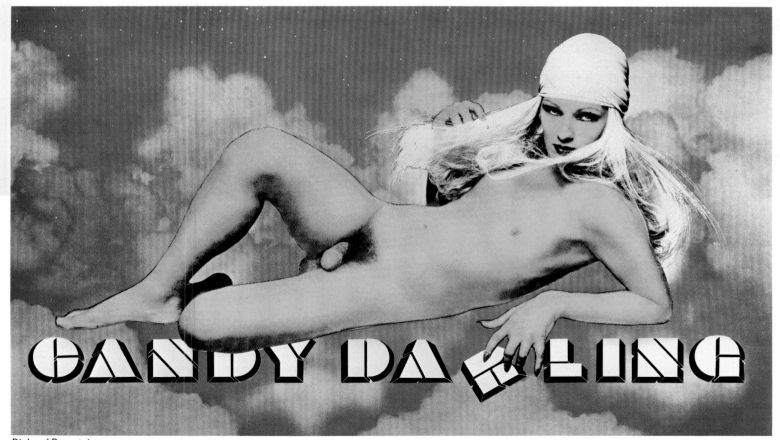

Richard Bernstein

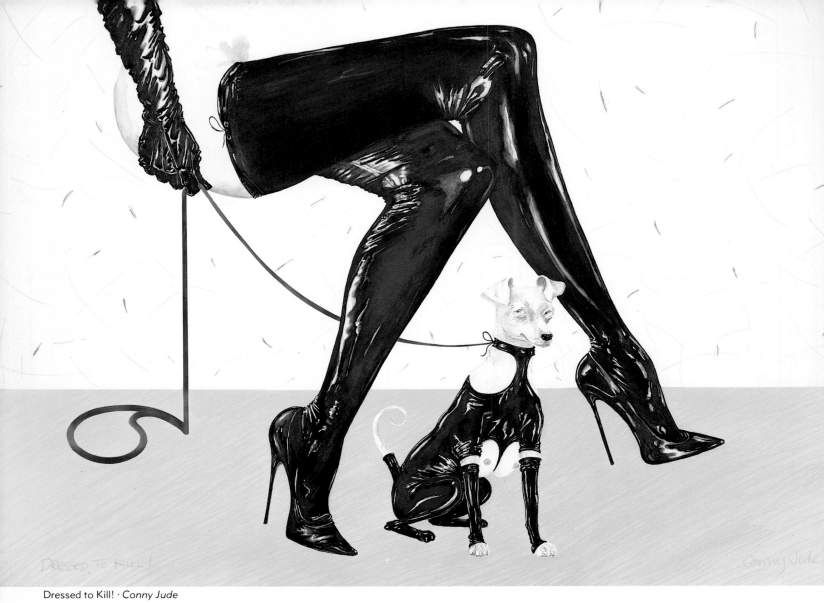

Dressed to Kill! · *Conny Jude*

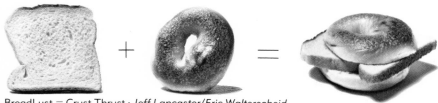

BreadLust = Crust Thrust · *Jeff Lancaster/Eric Walterscheid*

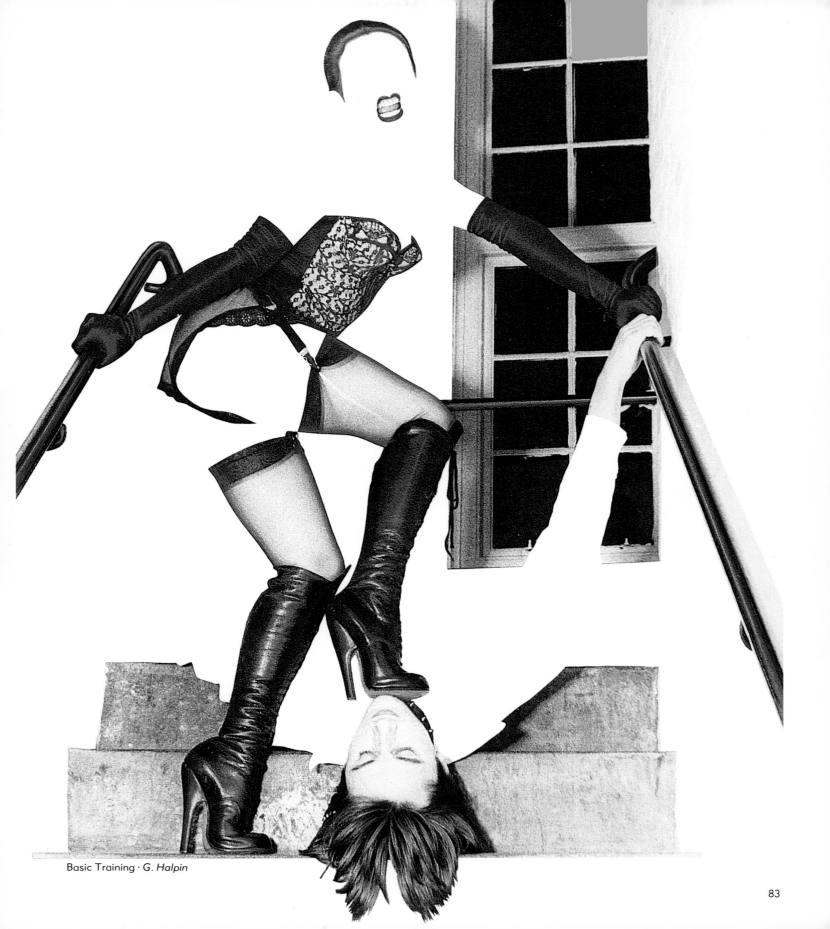

Basic Training · *G. Halpin*

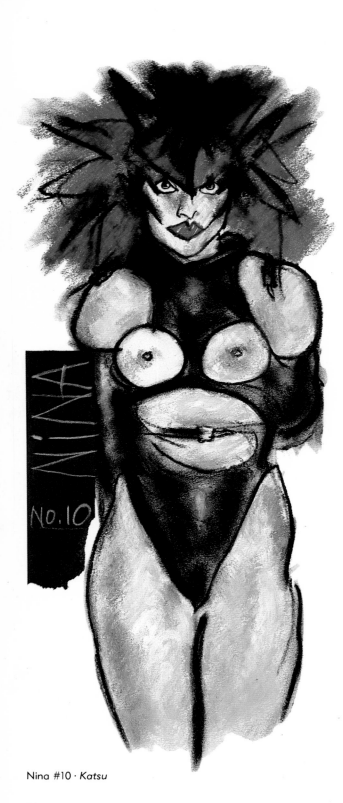

Nina #10 · *Katsu*

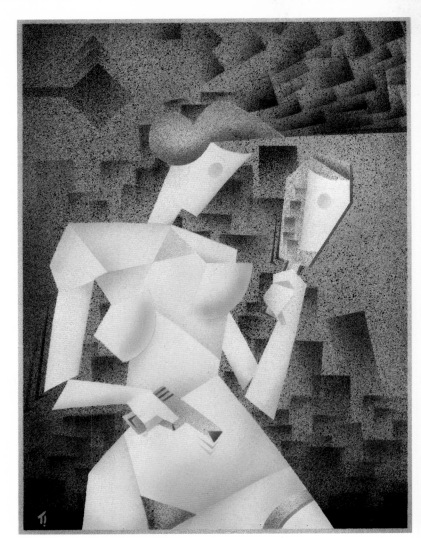

Mirror, Mirror · *Francois Robert*

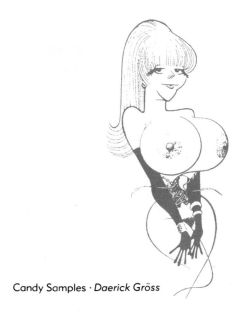

Candy Samples · *Daerick Gröss*

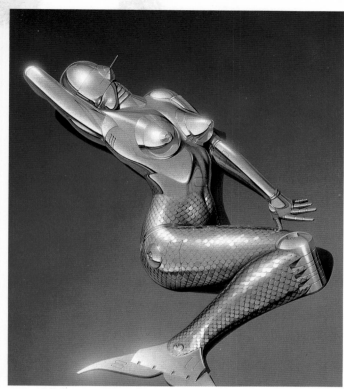

Marilyn the Mermaid · *Hajime Sorayama*

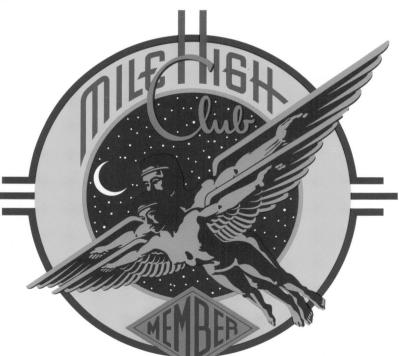

Mile High Club · *Michael Doret*

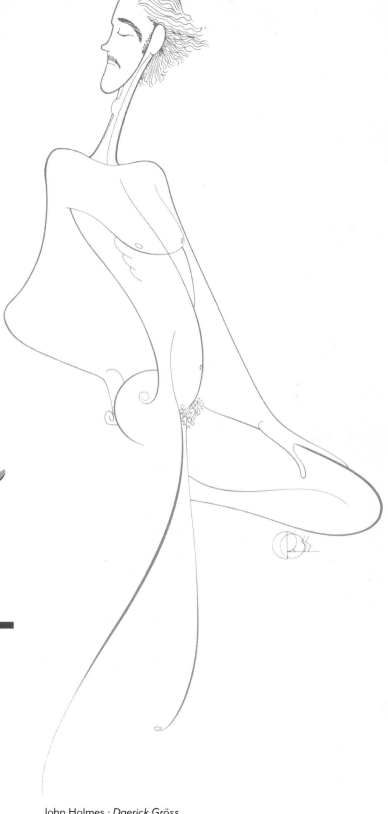

John Holmes · *Daerick Gröss*

Gary Panter

Gary Panter

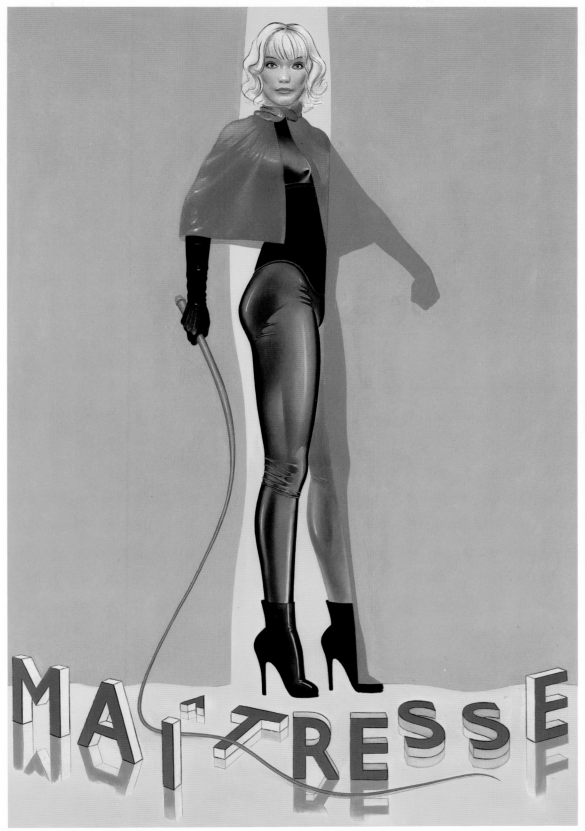

Maîtresse · Allen Jones 1975

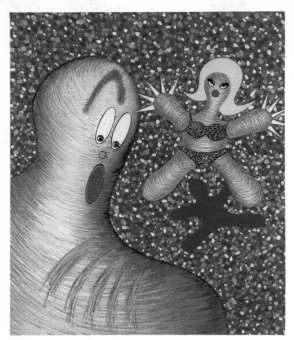

Claws · *Laurie Rosenwald*

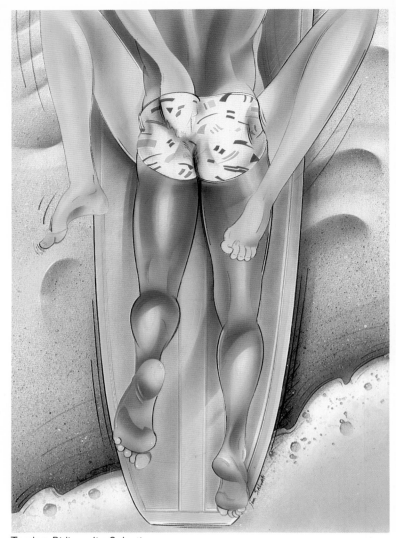

Tandem Riding · *Jim Salvati*

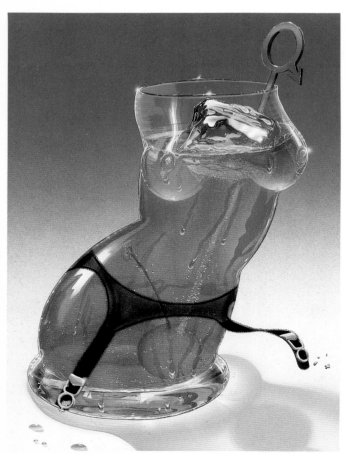

Pink Lady · *Chris Hopkins*

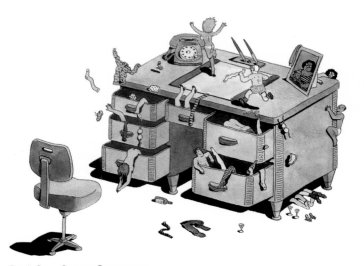

Desk Sex · *Steven Guarnaccia*

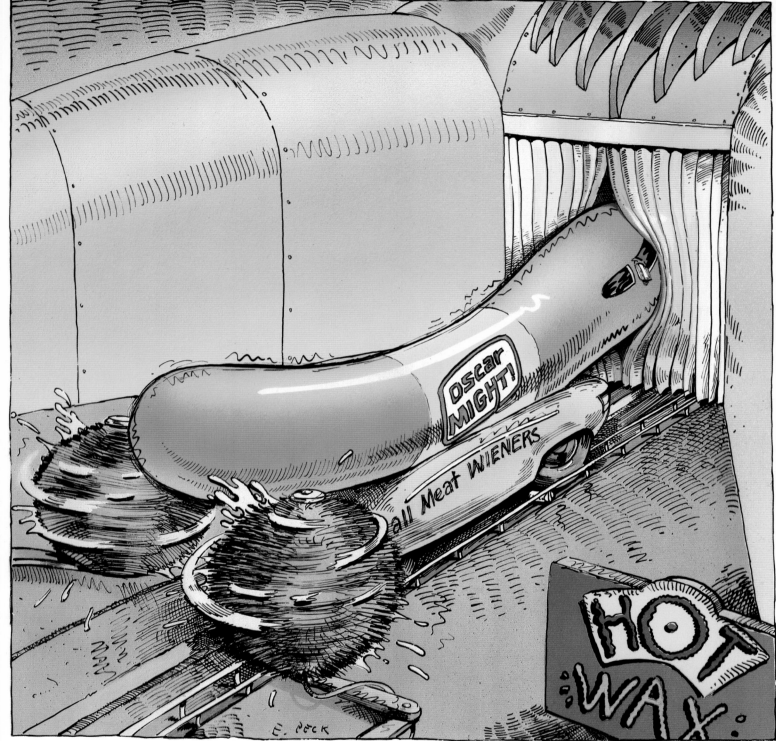

Hot Wax · *Everett Peck*

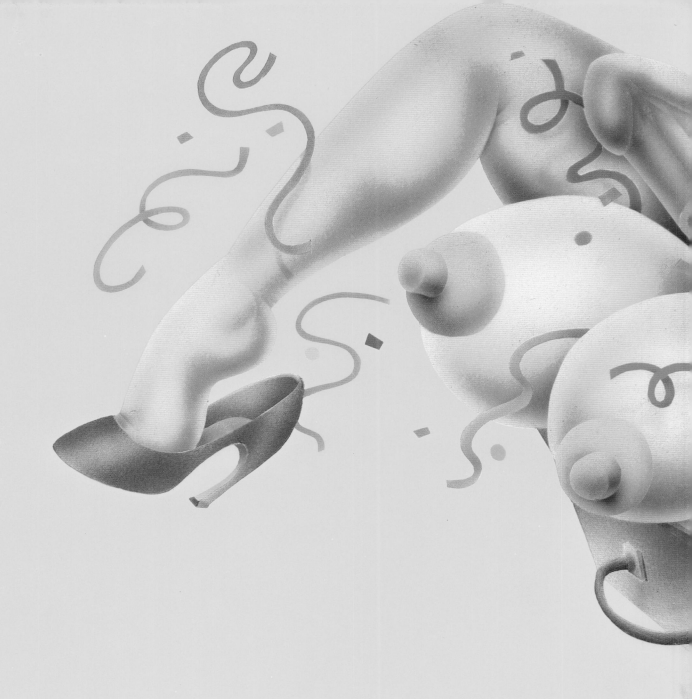

The Office Party · *Tom Hachtman*

90

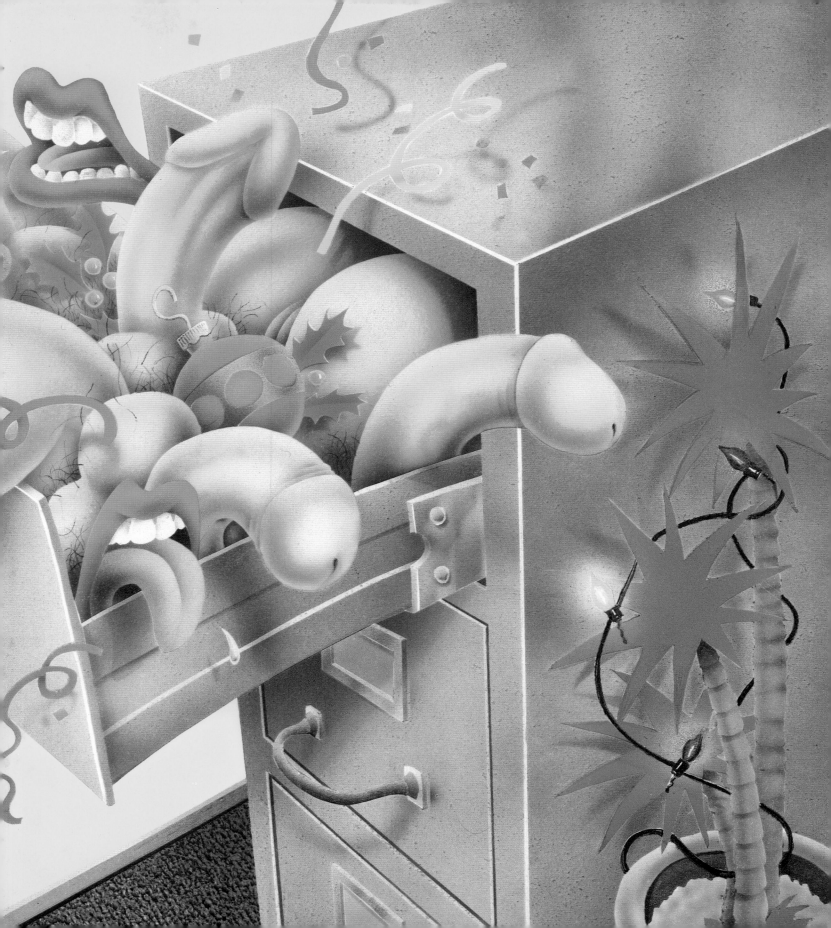

Customs · *Rod Dyer*

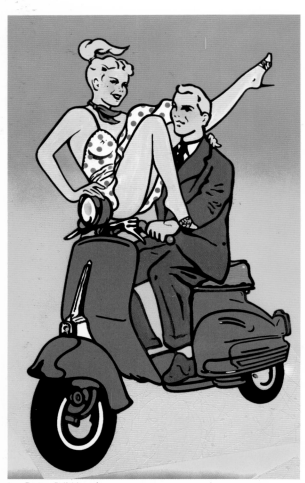

Joy Ride · *Bill Murphy*

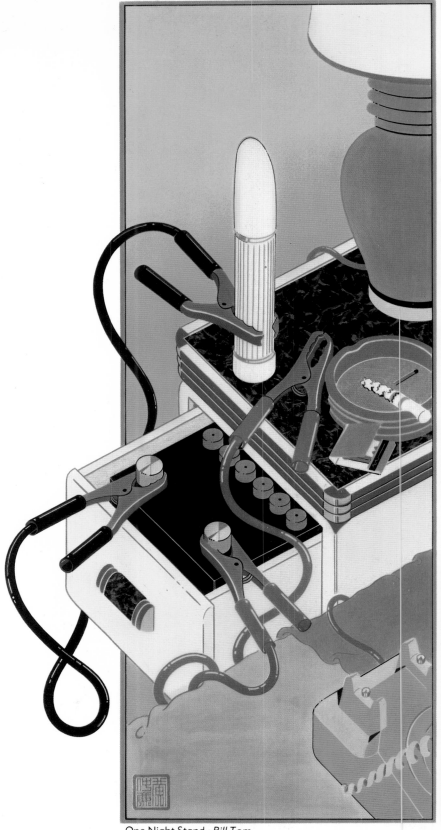

One Night Stand · *Bill Tom*

92

the body as the scrotal skin becomes tense and thick. The interior of the vagina begins to turn a darker pink and lubricate with a pearly fluid as the uterus begins to lift off the floor of the vaginal barrel. As excitement increases, the interior two thirds of the vagina go through waves of expansion and relaxation, becoming larger as if to make room for the penis. The penis becomes more sensitive, with the tip becoming extremely sensitive. The inner lips of the vagina swell and deepen in color to a rich, rosy plum. The female breasts enlarge as much as 25 percent, nipples become erect and sensitive. The penis may emit a clear liquid as a lubricant. (This liquid usually contains a small amount of sperm, which means that withdrawal before orgasm is no gurantee of contraception.)

Breathing and pulse rates continue to increase. Blood pressure rises. Muscle tension becomes stronger and stronger. Women may show a blotchy measleslike (maculopapular) flush over the legs, thighs and pelvic area. Lying on your back, you may experience carpopedal spasms (both men and women), which means your toes curl up. The inner two thirds of the vagina continue to enlarge and become smoother, but the outer one third becomes smaller and tighter, increasing the sensation between a thrusting penis and the outer vagina. The clitoris retracts under a clitoral hood. In intercourse, the thrusting of the penis pulls the inner lips of the vagina, which in turn pulls the clitoral hood

Bob Zoell

"BOSOMANIA"

(OR FORTUNATELY, IN LIFE, LITTLE THINGS GO UNREWARDED)

Sing Along
(With due respect to Mr. Meredith Wilson and his "Trouble in River City" from "The Music Man")

"WELL, WE GOT FUN
I SAY FUN, RIGHT HERE
IN WAUKESHA

YES SIR, WE GOT IT ALL, HARRY
FUN, FUN, FUN
TWO OF EVERYTHING NICE
ROTUNDITY, GLOBULARITY
ORBICULARITY AND GLOBOSITY
SURE, WE GOT FUN, BIG FUN
REALLY BIG, SMOTHERING FUN

POUTING, BULGING
ARCHING, BALLOONING
PROJECTING, THRUSTING
ROUSING, SWELLING,
BUTTRESSING, GRAVITY
-DEFYING

WELL, YOU GOT FUN, SLICK
RIGHT HERE IN WAUKESHA
FUN WITH A CAPITAL "J," AND
THAT RHYMES WITH "K," AND
THAT STANDS FOR KNOCKERS
AND I MEAN REALLY BIG ONES
SURGING, QUIVERING
HEAVING, SWAYING
INTOXICATING, TANTALIZING
BOUNCING, SUFFOCATING
YES, EVEN OVER-WHELMING!

YES, I SAID FUN HOMER LEE
REALLY BIG, HUMUNGEOUS,
MIND-SUCKING FUN
INTIMIDATING, SMOTHERING
CUPPING, KNEADING
SQUEEZING, MILKING
JETSONING, EXPLODING!
 YES SIR, RIGHT HERE
 IN WAUKESHA
EXCELSIOR WITH A CAPITAL "E,"
AND THAT RHYMES WITH "B,"
AND THAT STANDS FOR
 BIG BAZOOMS

PEAR-SHAPED, CONICAL CANS
ARROGANT, CANTILEVERED
 BEEHIVES
JUTTING, SOARING
TEMPESTUOUSLY HIGH-FLYING
AWESOME, SUPER-STACKED
MELONS! BEHOLD, ABUNDANCE
RIGHT HERE IN WAUKESHA
EUREKA WITH A CAPITAL "E,"
AND THAT RHYMES WITH "B,"
AND THAT STANDS FOR
 BAZOOKAS

BUBS, BUBBLES, BULINGS,
 AND BALLOONS
PELOTAS, BRISTOLS, UDDERS,
 AND HANDLES
YES, LET'S SAY IT
EVEN CANNONBALLS,
 BUT SUPER BIG ONES
SEETHING, THROBBING, AND
 STUPEFYING

TURBULENT, TEMPESTUOUS,
 AND THRILLING
SLAPPING, SPANKING,
THUMPING, AND WHACKING
LARGER, BIGGER
BIGGER THAN BEFORE
FULL-BODIED, OVER-BLOWN
CAPACIOUS, WAY-WAY
 OVER ENDOWED
INFLATE, REFLATE
PUFF-UP, PUMP-UP
EVEN BLOW-UP
DOUBLE, REDOUBLE
TOWERING, MONUMENTAL,
MOUNTAINOUS BEHEMOTHS
LEGENDARY, MAMIFEROUS,
OVER-RIPE, MAGNUM MAMILLA!

YES SIR, ELMO,
WE GOT FUN, FUN, FUN!
RIGHT HERE IN WAUKESHA
XANADU WITH A CAPITAL "X,"
AND THAT RHYMES WITH "SEX,"
AND THAT STANDS FOR
 SOME KINDA' TITS!

(And then delivered with soft, breathy hunger)

AND I MEAN WATERMELONS!"

—Russ Meyer

© Copyrighted.
All Rights Reserved.

SMALL MEDIUM LARGE SAGGING

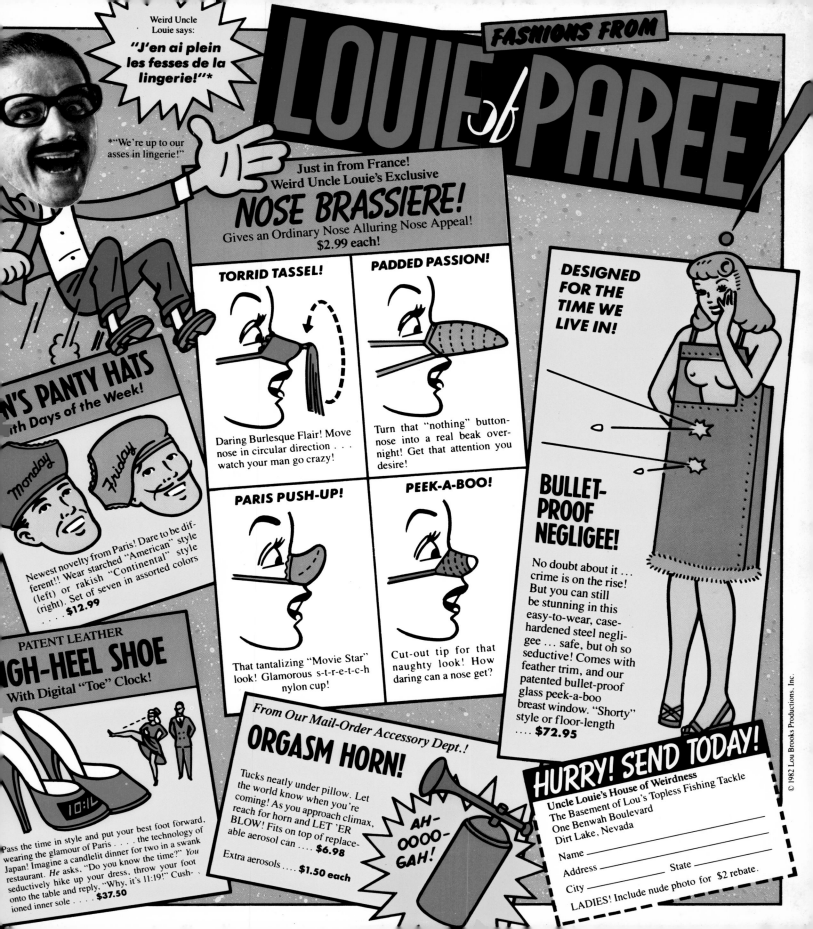

Index

Bob Zoell

Acknowledgements

I would like to thank the following for
their cooperation and assistance:

Andresen Typographics
GP Color/Cindy Lynch, George Harvey
Stat House
Wilcopy
Charlie Wild Studios, L.A.
Prudence Cuming Associates Ltd., London
NTA Studios, London
Pushpin Studios, N.Y.C.
Chris Whorf/Art Hotel, L.A.
Joel Beren/Ocards, N.Y.C.
Andy Warhol, Fred Hughes/The Factory, N.Y.C.
Sidney Janis Gallery, N.Y.C./Mary Mulcahy
Louis K. Meisel Gallery, N.Y.C.
O.K. Harris Galley, N.Y.C.
Hugh Hefner/Playboy Magazine
Michael Hodgson/Playgirl Magazine
Hiroko Tanaka/Illustration Magazine, Tokyo
Interview Magazine
Art Direction Magazine
Rolling Stone Magazine
National Lampoon Magazine
Penthouse Magazine
Time Magazine
Chic Magazine
Hustler Magazine
Esquire Magazine
GQ Magazine
New York Magazine
Los Angeles Magazine
California Magazine
Oui Magazine
Blueboy Magazine
Club Magazine

Russ Meyer
Jack and Joan Quinn
Mel and Leta Ramos
Mr. and Mrs. Eliot Sherman
Cis Rundle
Daniela Morera
Ed Taylor
Mike Fink
Robert Fitch
Fred Zax and Linda Barton
Kyoko Tsuchihashi
Bill Cohn and Russ Berens
Joan Love Allemand
My Family and Friends
American Showcase
 Ira Shapiro
 Chris Curtis
 Fiona L'Estrange

Underwear and accessories from
the collection of Mr. Brian Zick

THANK YOU Harry Thomas

Special Thanks
 Bruce Vilanch
 Marilynn Preston
 Peter Palombi

With much respect to the memory
 of Bea Feitler

Any omission of credit is inadver-
 tent and will be corrected
 in future printings if notifica-
 tion is sent to the publisher.